REAL PHOTO POSTCARDS

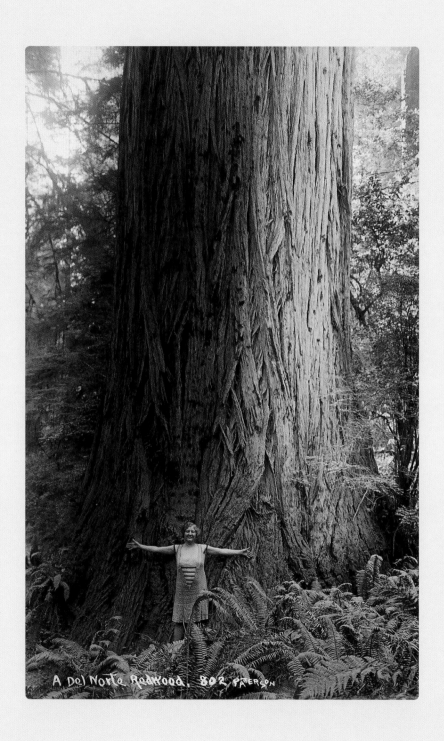

A Del Norte Redwood. 802 Paterson

REAL PHOTO POSTCARDS

..

UNBELIEVABLE IMAGES

FROM THE COLLECTION OF

HARVEY TULCENSKY

EDITED BY LAETITIA WOLFF ESSAY BY TODD ALDEN

PRINCETON ARCHITECTURAL PRESS

NEW YORK

TO MARJORIE WARD

WHOSE HOME I NOW LIVE IN

...

Published by

Princeton Architectural Press

37 East Seventh Street

New York, New York 10003

For a free catalog of books, call 1.800.722.6657.

Visit our web site at www.papress.com.

[Frontispiece]
Collector's note: A Del Norte Redwood

Editing: Jennifer Thompson
Design: Paul G. Wagner

Special thanks to: Nettie Aljian, Dorothy Ball,
Nicola Bednarek, Janet Behning, Megan Carey,
Penny (Yuen Pik) Chu, Russell Fernandez, Jan Haux,
Clare Jacobson, John King, Mark Lamster,
Nancy Eklund Later, Katharine Myers, Lauren Nelson,
Jane Sheinman, Scott Tennent, Joseph Weston,
and Deb Wood of Princeton Architectural Press
—Kevin C. Lippert, publisher

Library of Congress Cataloging-in-Publication Data

Real photo postcards : unbelievable images from the
collection of Harvey Tulcensky / edited by Laetitia Wolff ;
essay by Todd Alden.—1st ed.
p. cm.
"Postmarked : Real Photo Postcards 1907-1927 from the
collection of Harvey Tulcensky at K.S. Art, in New York,
2004"—P. 204.
Includes interview with artist.
ISBN 1-56898-556-8 (alk. paper)
1. United States—Social life and customs—20th
century—Pictorial works. 2. Americana—Pictorial works.
3. Postcards—United States. 4. Tulcensky, Harvey—
Photograph collections. I. Tulcensky, Harvey. II. Wolff,
Laetitia. III. Alden, Todd. IV. K.S. Art (Gallery).
E169.R277 2005
973.91'022'2—dc22
2005047547

AND WE LIVED WHERE DUSK HAD MEANING

REMEMBERING REAL PHOTO POSTCARDS

BY TODD ALDEN

Although a commonplace form of popular culture, real photo postcards remain a relatively neglected province of photographic history, one that sustained its strongest popular interest between 1907 and 1930. The selected postcards in this book were all acquired by Harvey Tulcensky, an artist with an artist's eye.[1] Neither this collection nor the following remembrances attempt to unpack a general history of real photo postcards, but rather marvel at their particularities and unique properties. These approaches represent a particularly personal vantage onto a class of vernacular photographs that have been mostly forgotten in attics or gone missing in the dustbins of everyday life. Unlike official histories of photography characteristically organized by author, theme, or chronology, this offering is more akin to a personal album, arranged according to *elective affinities*. Passing thoughts on passing things, these are inspired fingers pointing beyond the frame toward the furtive pleasures, idiosyncratic poignancies, and piercing wonders of the real world and self-reflexively, of course, to the singular wonders of real photo postcards themselves.

This admittedly poetic approach, however, does not aim to cast our gaze up toward the ether of universal constellations of art, but rather, zeroes in on the here-and-now. Intended to be sent through the mail for a particular and familiar audience, real photo postcards are time-bound registrations of particular things, events, people, or places. Sharing little in common with the pretensions of timeless art, these messages have a workmanlike quality, bearing the characteristic markings of a local, vernacular message intended to be useful only for a short period of time. Sometimes produced by great photographers, the discrete charm of real photo postcards, for me, however, derives instead from inspired, idiosyncratic visions, methods, and purposes rather than from professional values. This local, particular, and contingent emphasis is elaborated on the postcard's verso where handwritten captions and messages could also be added, thereby inscribing a personal relationship between sender (frequently the photographer) and original receiver.

So what are real photo postcards? The prototype of real photo postcards—real photo mailing cards—dates from around 1900, but differ from the former in that they could not allow for unique, written messages on the verso due to U.S. Postal regulations which forbade any messages whatsoever from being written on the backs of all postcards.[2] Real photo postcards began to proliferate dramatically in 1907, however, the year that the U.S. Postal Service allowed personalized messages to be written onto the postcards' preprinted, divided backs.[3] This postal sea change

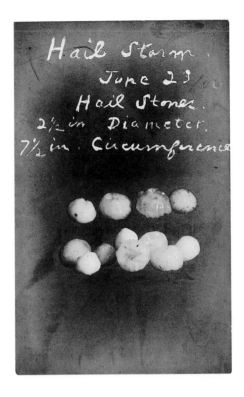

virtually coincided with Kodak's introduction of an affordable, easy-to-use porta-
ble, folding pocket camera the previous year. Photographic images were now print-
ed in black and white directly onto thick, sepia-toned card stock with preprinted
"postcard"-designated backs. The camera's postcard-sized negatives gave the
printed cards greater clarity in contrast with the vast majority of postcard images
otherwise composed of small dot patterns printed on a lithographic press.[4] Some
of Kodak's cameras also included a window at the rear of the camera through which
the operator could scratch a caption or message directly onto the negative with a
metal tool. Such an incision was used, for example, to scrawl onto the surface
of a card capturing giant hailstones. This homespun, do-it-yourself image/message
conjures up the wonder and process of discovery that amateur photographers were
only beginning to explore: previously illusive or ephemeral images of quotidian
life—a giant trout, an arrested eclipse, a neighbor sledding, a local fire—could now
be captured and witnessed by virtually anyone.

Instead of communicating with commercially produced or government-
published postcards of lithographic generalities (and it is worth noting that 75%
of these extremely popular cards were printed in Germany during the first decade
of the twentieth century), legions of industrious amateurs chose to make and

distribute their own self-generated, vernacular images. Attention to local detail, therefore, also distinguishes real photo postcards from what are said to be the first American postcards—so-called "souvenir cards" issued by the government at the Chicago Columbian Exposition of 1893. Although professional photographers were significant producers of real photo postcards—and some of these widely re-produced commercial cards are included in this book[5]—amateurs produced and exchanged idiosyncratic views of the world beyond the scope of images otherwise found embedded in professional photography.

Photographic postcards such as these were made possible by the de-profes-sionalization of photography and ushered in with Kodak's early slogan, "You push the button, and we do the rest." This allowed for the proliferation of cameras bought by novices and entrepreneurs, who sought out contingent, inaccessible, and above all, local subjects: someone's wife, dwarfed by "a Delnorte Redwood"; an abundant apple-bearing branch with "four appels [sic] not shown...grown by G.W. Stone, Aztec, N.M"; a photograph of snowflakes by Vermont's legendary amateur farmer-scientist, Snowflake Bentley who dedicated himself to the hobby for years (and who subsequently died of pneumonia, after pursuing snowflakes). Of course Bentley's obsessive pursuit of photographing snowflakes yielded the ultimate collision of contradictions: between the image-fixing character of photog-raphy—that which promises, theoretically at least, to return endless copies of the same—versus the ephemeral, heterogenous character of nature (and its infinite sup-ply of unique variations).

What real photo postcards initially delivered was a space capable of registering the infinite variety of photographic possibility; even when commercialized in the popular form of travel or tourist cards, they frequently manage, nonetheless, to multiply heterogeneity and to resist classification. In an era of increasing homoge-nization, digitization, and mediatization, we are drawn to real photo postcards for their particularity, for their "authenticity," and for their fugitive, time-bound regis-trations of the here-and-now. To see them today is to recall the dawn of vernacular photography and the luminous, fugitive wonder of its early registrations. To see them today is to recover sepia-toned facts and desires—otherwise mute, forgotten, or without further witness—that remain inscribed with the hushed presence of the not-quite-passed. To see them today is to remember the wonder, to remember we lived where dusk had meaning.

Like other photographic indices, they cut us to the quick by reinscribing *that which was* in the present tense of *that which is*. But while they do reflect—along with photography in general—a unique relationship to the real, it is problematic to suggest that they reflect a purely "authentic vision" or "unfiltered truth." Know-ingly or not, amateurs would adopt the visual rhetoric of "professional" photo-graphy (or even "professional" painting) and what is more, they sometimes play-ed also with photographic fictions. One of my favorite types of professionally

produced real photo postcards, widely distributed at the time is the "exaggeration" card, consisting of *trompe-l'oeil* photos, for example of exaggeratedly gargantuan animals, fruits, and vegetables that were neither straight photographs nor "real" facts but rather seamless examples of photomontage. Still, some of the pleasure they delivered derived, no doubt, from their winking, paradoxical claims to representing truth. Even though "exaggeration" cards were distributed as more commercial "souvenir cards," these commemorative oddments still manage to communicate with unofficial, local, and quirky dialects.

Snapshots were intended, for the most part, as private commemorations, but real photo postcards, on the other hand, supported other purposes: to engage brief communication over long distances, especially significant in the pre-telephone era. Modest, idiosyncratic, and above all unique—even when they were widely reproduced—real photo postcards retain a special access to particular, time-bound messages, especially when the sender was also the photographer; the postmark on the address side of the card, however, does not cancel their uncanny power to deliver their arresting registrations of the here-and-now to the present viewer, one more time with feeling. These are not impersonal, timeless, official views but rather idiosyncratic messages whose passing impressions of passing things pierce us with the particularity of what Roland Barthes described as a photograph's punctum, "this wound, this prick, this mark made by a pointed instrument." Then as now, piercing wonders.

New York / February 1, 2005 / 9:41 A.M.

...

1 A shorter version of this essay was originally published on the mailed exhibition announcement of the exhibition, *Postmarked: Real Photo Postcards 1907–1927 From the Collection of Harvey Tulcensky* at K.S. Art, in New York, 2004. For his singular vision and real friendship, warm thanks to Harvey Tulcensky. For Kerry Schuss whose enthusiasm and generous support made possible the first version of this opuscule, a most appreciative nod and a wink. For Laetitia Wolffe, kudos for taking this to the bridge.

2 Before 1907, mailing cards (with either lithographic or the far less common photographic fronts) unlike the slightly later real photo postcards—were not allowed to have pre-printed, divided backs onto which a message could be written at left and the address at right.

3 The craze for all types of postcards was extraordinary at this time. The U.S. Postal Service estimates that almost 688 million (mostly lithographic) postcards were mailed in the United States in 1908 alone.

4 Lithographic cards, infinitely more common than real photo postcards, were already popular at the end of the nineteenth century and became increasingly so after 1907; the majority of lithographic cards around this time were printed in Germany, a stark contrast, of course, to the local production of real photo postcard. Printing options varied at the advent of amateur photography; early on, Eastman Kodak offered customers the option of mailing the entire camera (including the sometimes scratched negatives) back to its New York factory for developing. Probably the vast majority of amateur-produced real photo postcards were only printed a single time—unlike commercial cards by professional photographers.

5 Professional cards are sometimes distinguishable from amateur ones because photographers frequently inscribed their name or copyright into the photographic negative.

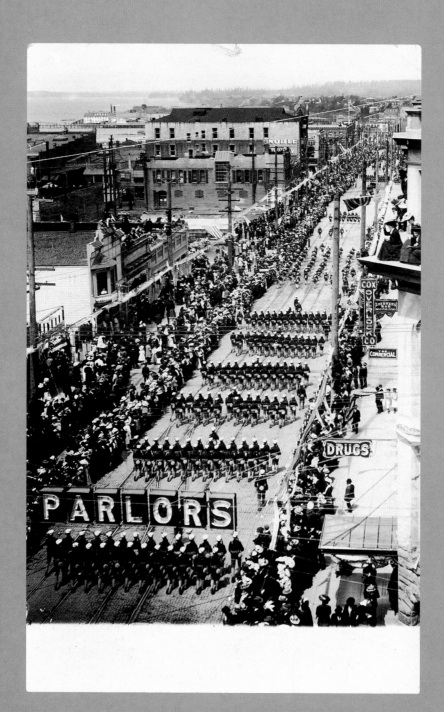

PARADING

Notice double exposure

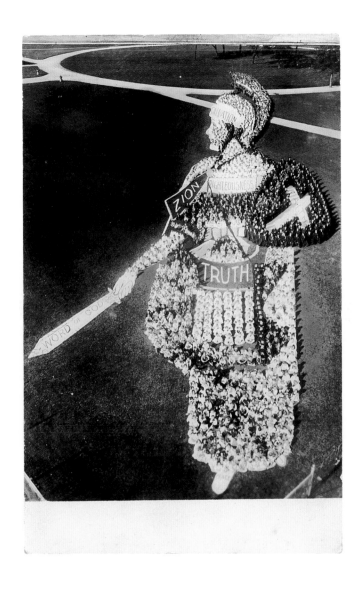

COLLECTOR'S NOTE:

Aerial view of human sculpture in the shape
of a centurion of the "Word of God"

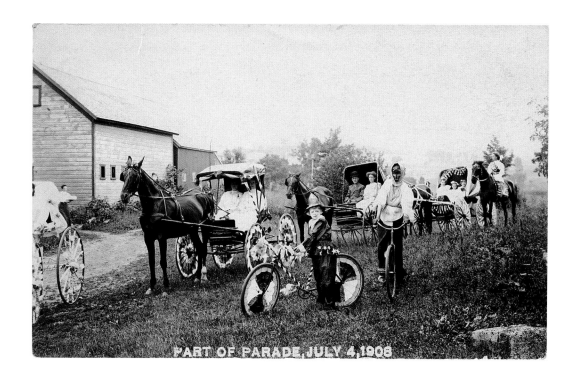

PART OF PARADE, JULY 4, 1908

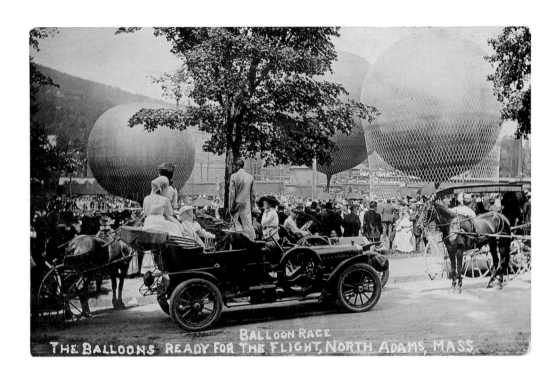

BALLOON RACE
THE BALLOONS READY FOR THE FLIGHT, NORTH ADAMS, MASS.

HANDWRITTEN:
Dear Friends:—
Hope you are well and it seems a long time
since we saw you, so we might make a call some
Sunday for a little while. Your Friend,
C. L. Krause

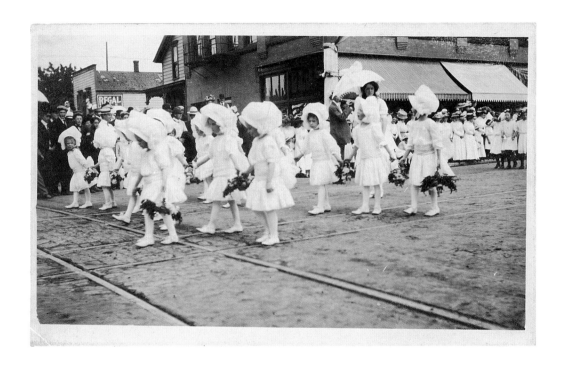

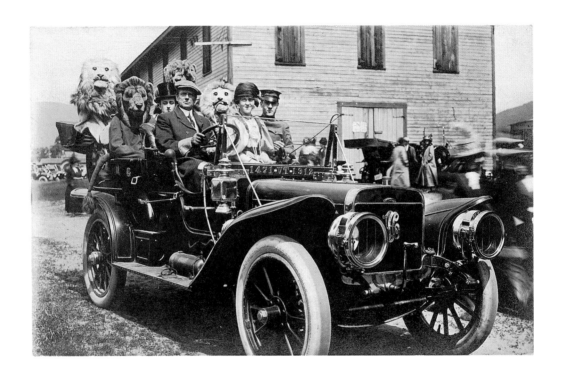

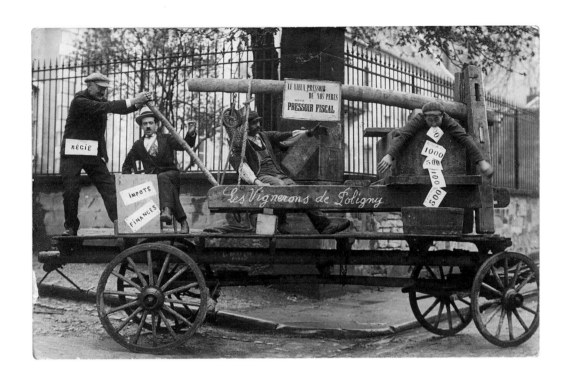

STAMPED:

L. BARBAUD

PHOTOGRAPHE

ARBOIS (Jura)

TRANSLATION OF TEXT ON CART:

The old wine press of our fathers turned into a fiscal press. The vintners of Poligny

COLLECTOR'S NOTE:

A taxation protest

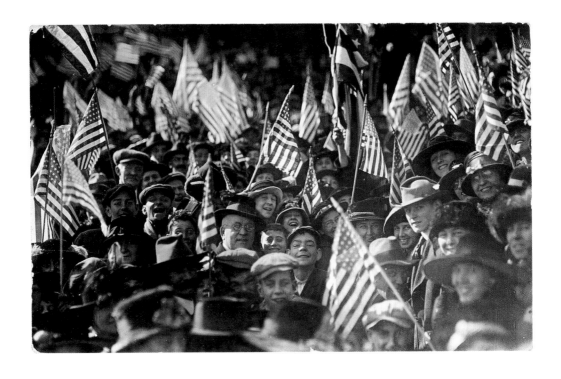

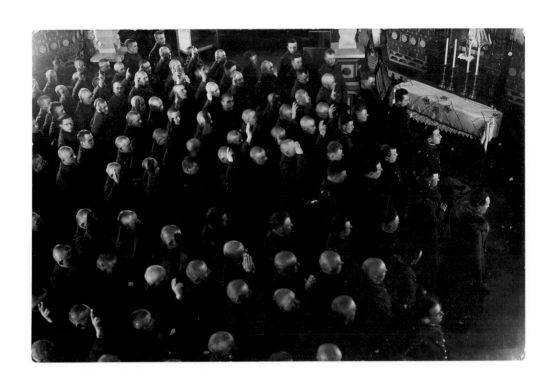

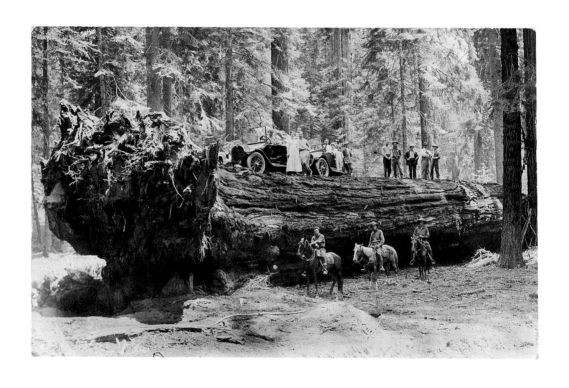

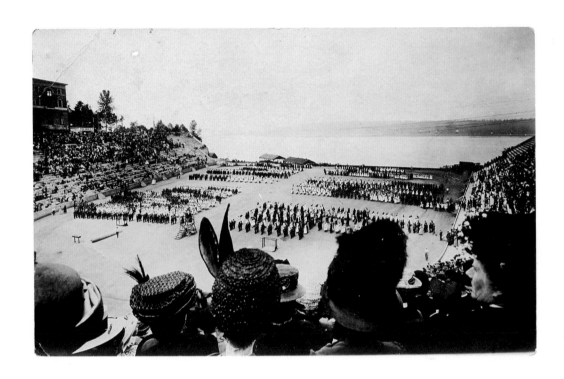

TYPEWRITTEN:

Cathlamet, Wash. 7/21/11.

Dear Friends. Did not have time to come up to
see you on the fourth. Was up to Tacoma for three
days to see the folks. This card is a picture of the
stadium in Tacoma, it will seat seventy five thousand
people. Regards to all the folks.

Algeo.

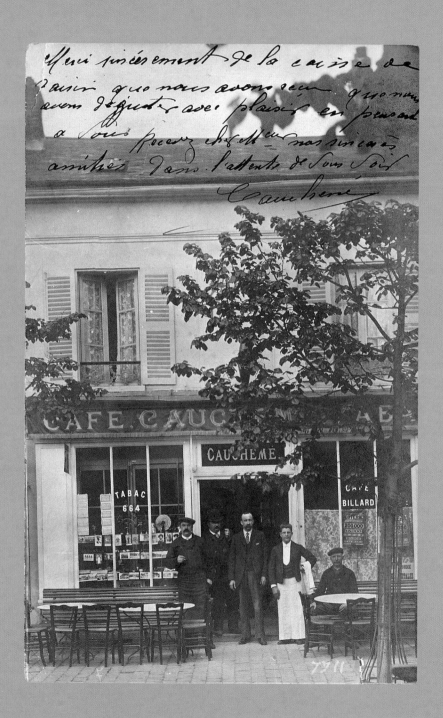

AT WORK

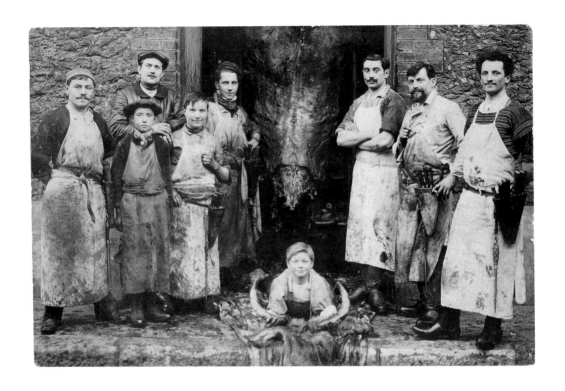

◄◄ *overleaf*
Béziers, Hérault (France)
August 21, 1904

above

COLLECTOR'S NOTE:

COLLECTOR'S NOTE:

Notice postcards in shop window

Butchers, Paris

HANDWRITTEN:

Here is your illustrious cousin in his native lair. I did not know I owed you a letter, but will write anyway tonight. Can you imagine <u>me</u> working. Note my pet bird. George.

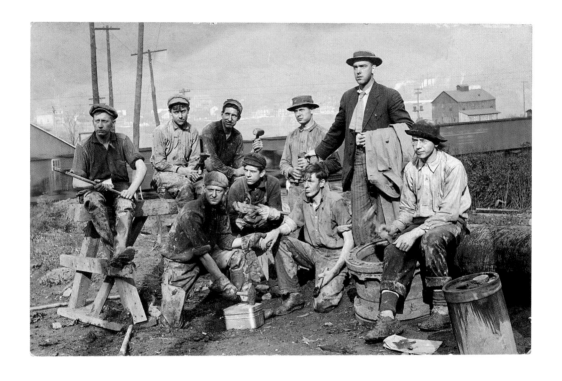

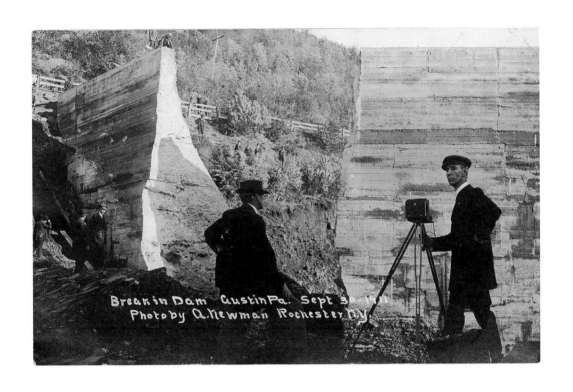

POSTMARKED:

Orlean, NY Oct 9, 1911

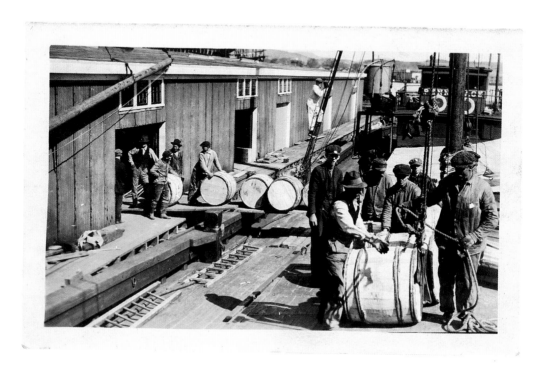

ROCKLAND
JUN 16
1 PM
MAINE

Dear Boy.
This is your father up on the ladder.
How are you. We had a big fire here last night.
Have not heard from Portland or Alice yet.
With love,
Papa

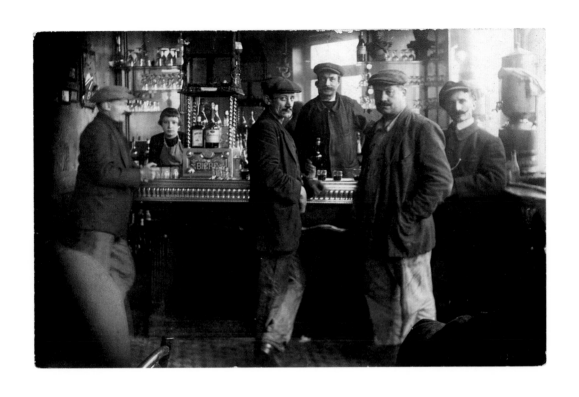

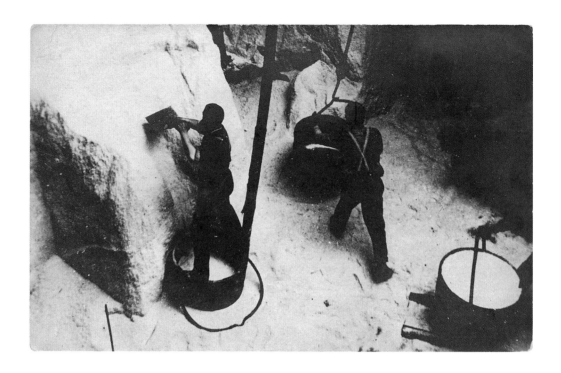

I am sorry that I was in Springfield when you were
in Gloucester. I was pleased to have our [sic] of
Howard's classmates take the trouble to look me up
and I appreciate it. This photo was taken in the hold
of a salt bark by the light of the salt itself. I hope it
may interest you.
Sincerely, Erna P. Albe

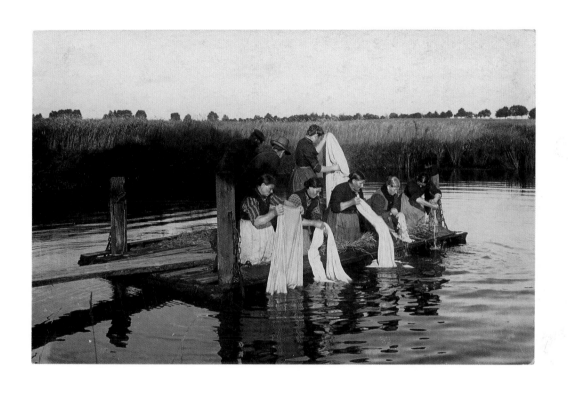

Probably France, date unknown

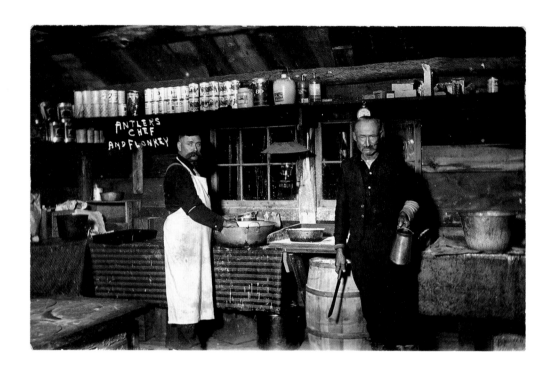

DEALER'S NOTE:
Antlers, Col. lumber camp

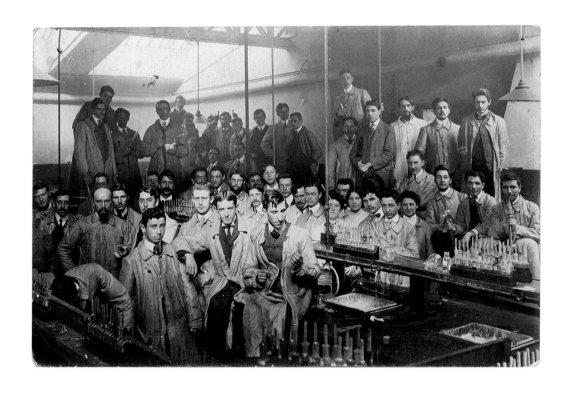

PRINTED:
R. Guilleminot, Doespflug et Cie.—Paris
COLLECTOR'S NOTE:
France, date unknown

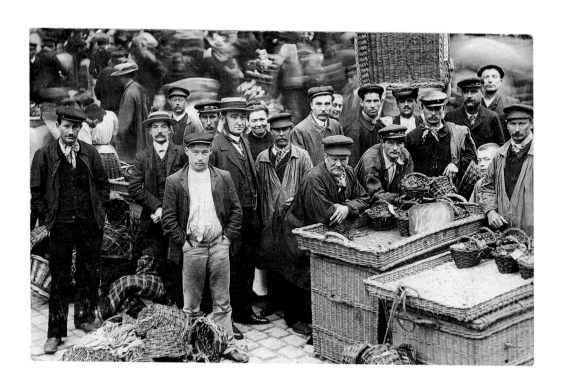

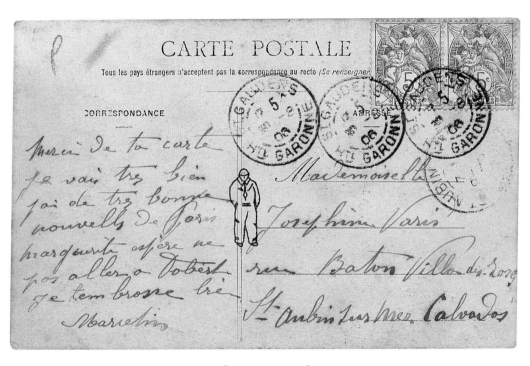

[*back of card at left*]

POSTMARKED:
St Saudens, Haute-Garonne (France)
7.5.1906

TRANSLATION:
Thank you for your card. I am very well, I have
great news from Paris. Marguerite hopes not to
go to Dobert. Kisses, Marcelin

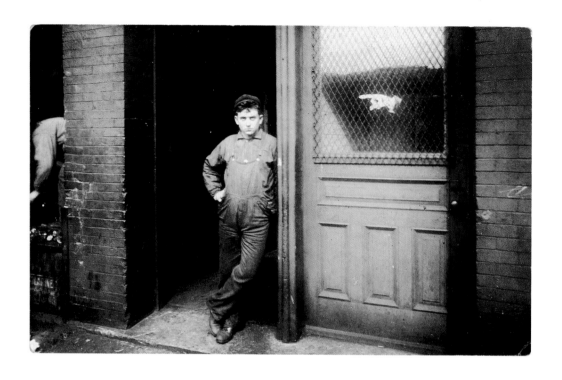

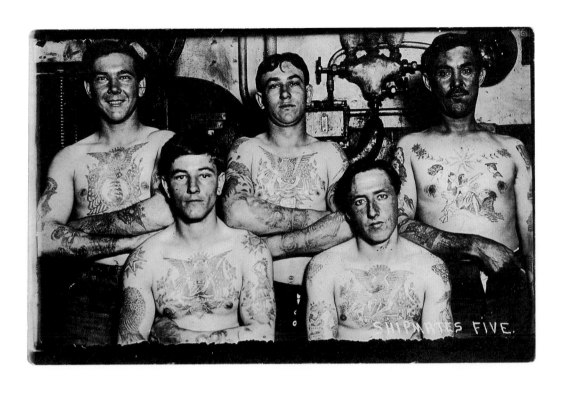

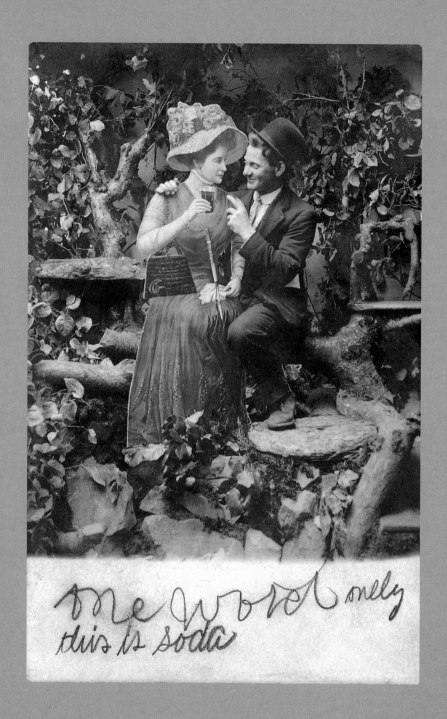

me word nly
this is soda

ROMANCE

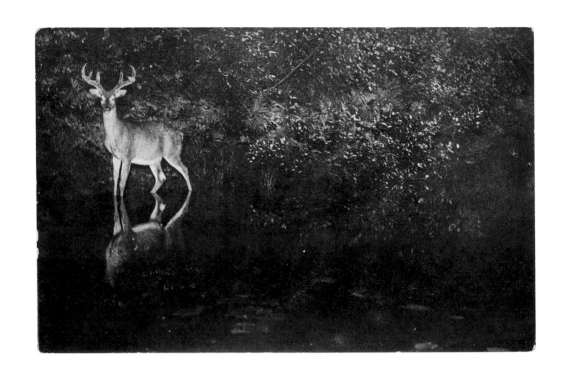

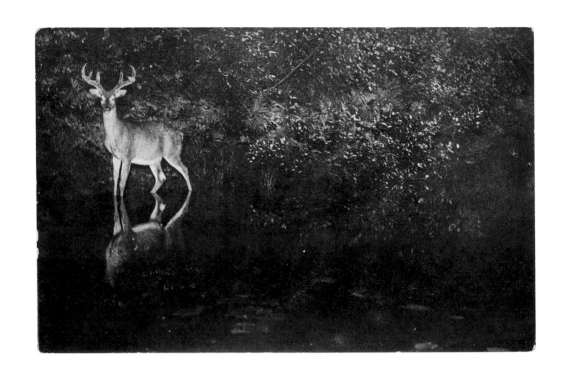 *overleaf*
PRINTED:

MA/—OGRAPH 10 minute postcards,
Portland OR

Highlights of moonlight reflected on the snow
are painted on the negative.

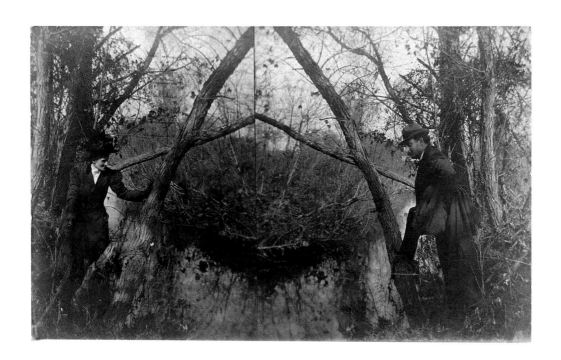

COLLECTOR'S NOTE:
A split exposure

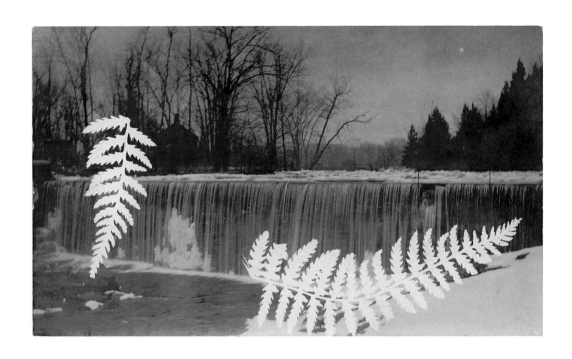

HANDWRITTEN:

Mr. Haight—
Enclosed find prints, these pictures are not
as good as I would like but they are just as they
are. If your people wish some made have them
write on the back of print—number them
also whether black or brown tone and send back.
As to the print of your house I think a picture
taken in the morning would be better as the trees
are too thick in front—(these prints will not
stand much light). Smith

COLLECTOR'S NOTE:

Exposure made with fern fronds placed over paper

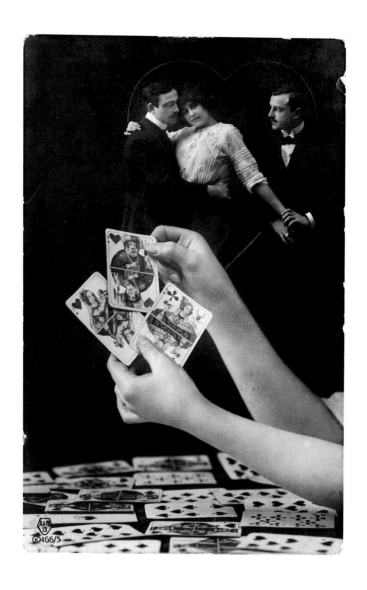

[*back of card at left*]

POSTMARKED:

HRADEC KRALOVE 2 * KONIGGRATZ

9.XII.13–1

COLLECTOR'S NOTE:

Fantasy card, probably Austria–Hungary

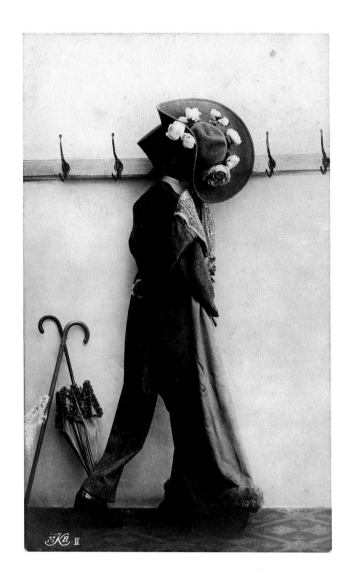

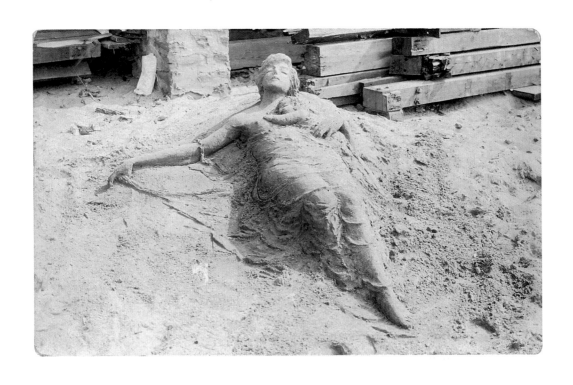

STAMPED:

MADE IN ERIE, PA., BY <u>JACK WEEKS</u>
WHILE U WAIT
BRANCHES AT WALDAMEER PARK
AND FOUR MILE CREEK.

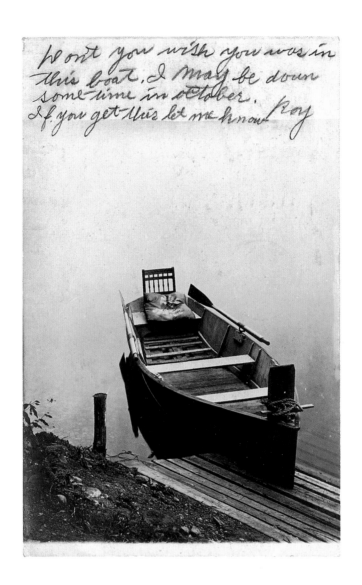

POSTMARKED:

Gloversville, NY

Sept. 19 1901 11-AM.

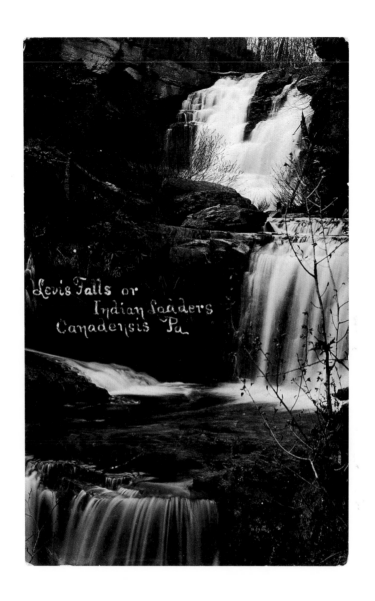

HANDWRITTEN:

My dear Mrs. Mack,
It is awfully lonesome up here now.
With lots of love.
Yours, Leillie

7455/4

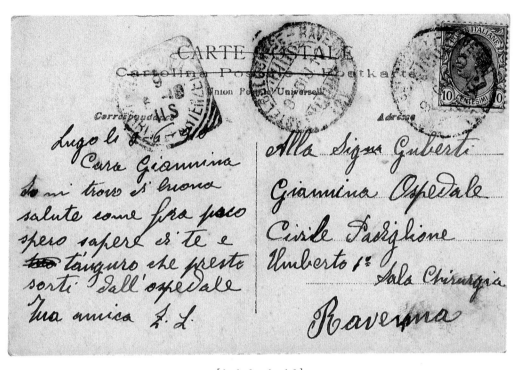

[*back of card at left*]

COLLECTOR'S NOTE:

A get-well card sent to someone
in the hospital (Italy)

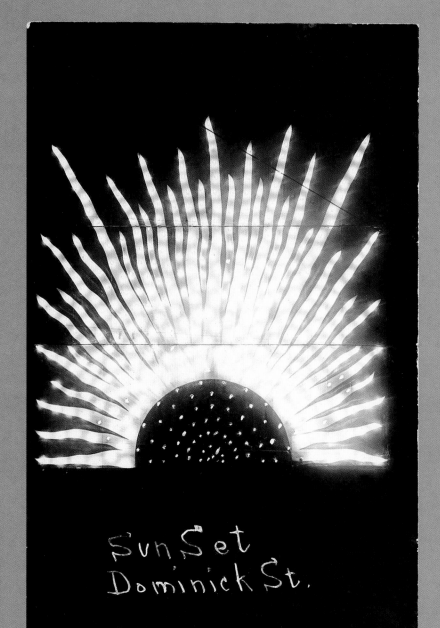

NIGHT & DAY

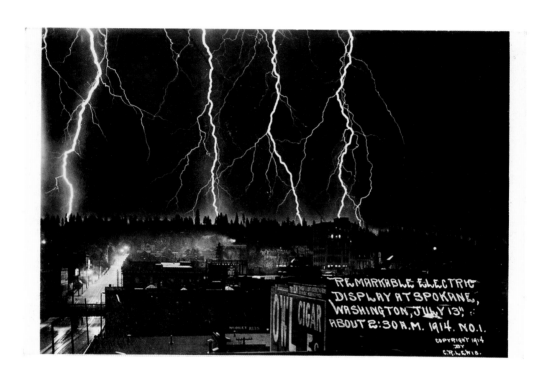

REMARKABLE ELECTRIC DISPLAY AT SPOKANE, WASHINGTON, JULY 13", ABOUT 2:30 A.M. 1914. NO. I. COPYRIGHT 1914 BY C.R.LEWIS.

OWL CIGAR

◄◄ *overleaf*

POSTMARKED:
Rome, NY Oct 23, 1911

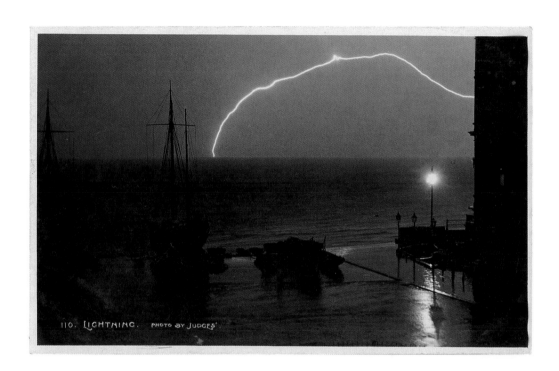

110. LIGHTNING. PHOTO BY JUDGES'

HASTINGS
2 PM
AUG 7
1911

HANDWRITTEN:

Dear Aunt Mary,
Am down here for two weeks. Lovely Place.
This is what I do not want to see. Give my
love to all. From Ada

PRINTED:

This card is an actual photograph,
taken and printed by Judges' Ltd.
Photographic Publishers, Hastings (England)

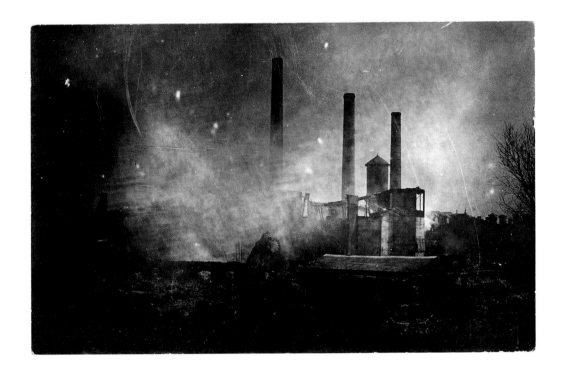

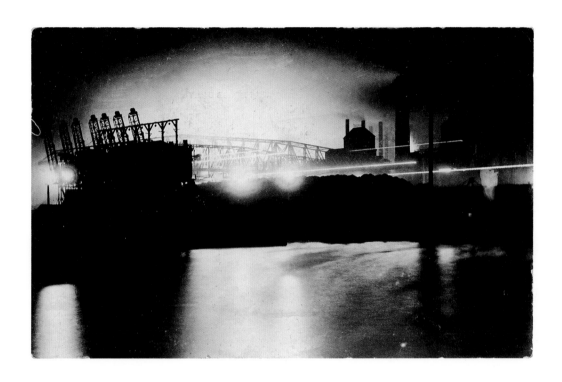

HANDWRITTEN:
Chicago 9-4-07
Card received.
Other side shows the Illinois Steel Co.
plant by night; am working there now.
How do you like the "Quake" town.
Note change of address.

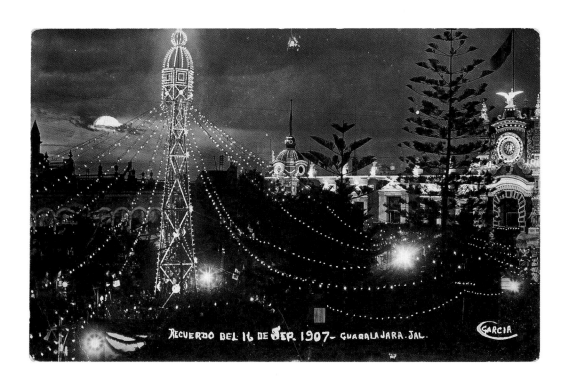

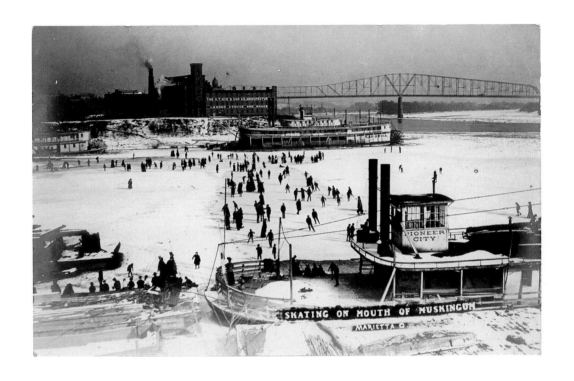

Image caption on photo: SKATING ON MOUTH OF MUSKINGUM. MARIETTA, O.

PRINTED:
From H. P. Fisher's Studio, Marietta, O.

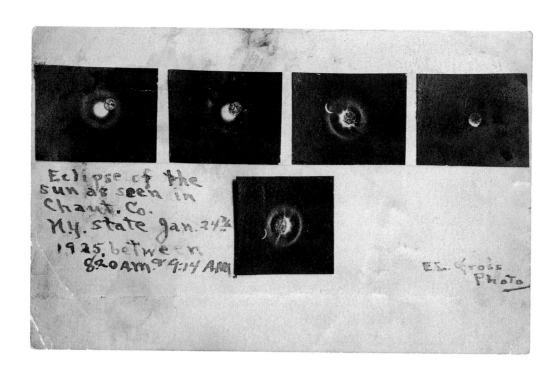

Eclipse of the
sun as seen in
Chaut. Co.
N.Y. state Jan.24¾
1925. between
8:20 AM & 9:14 AM

E.L. Gross
Photo

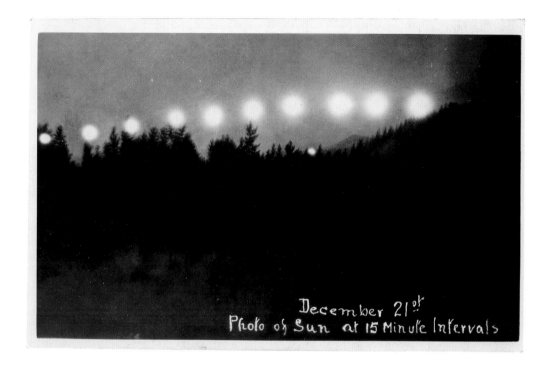

December 21st
Photo of Sun at 15 Minute Intervals

POSTMARKED:

White Horse, Jul. 15, 1933
Canada

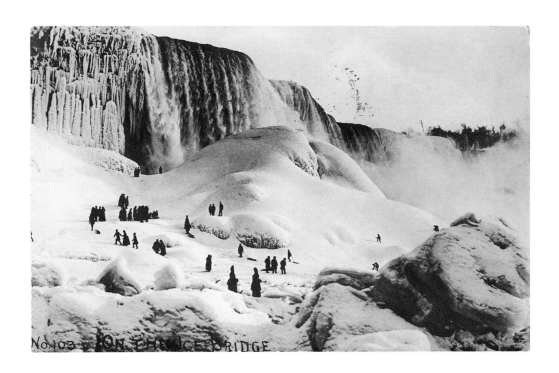

No. 103 ON THE ICE BRIDGE

HANDWRITTEN:
Dear Clara, 3/3/17
Reached here a little too late to see the
Falls in their Winter Splendor. Yet there
is considerable frost and an interesting
sight to view.
Regards to all, Rudi

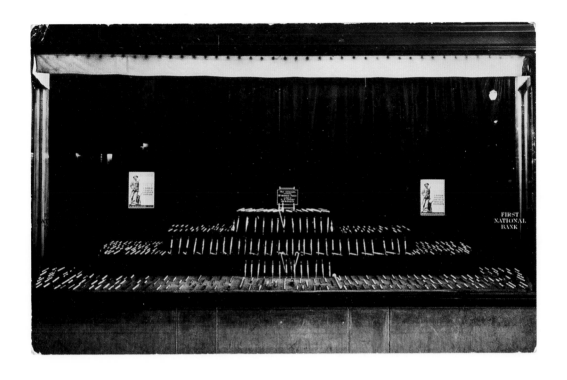

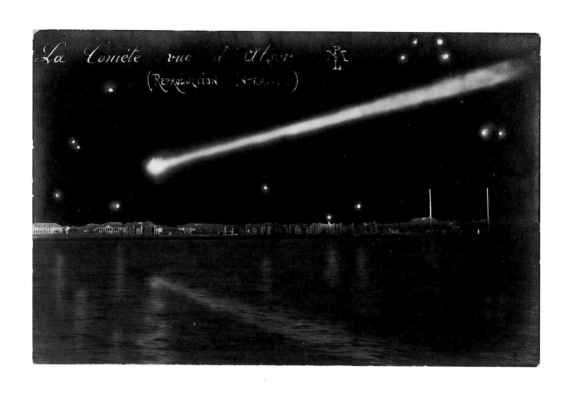

La Cómete vue d'Alger
(REPRODUCTION INTERDITE)

COLLECTOR'S NOTE:

Enhanced image

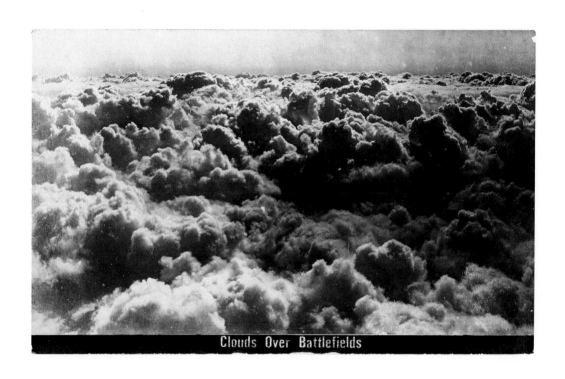
Clouds Over Battlefields

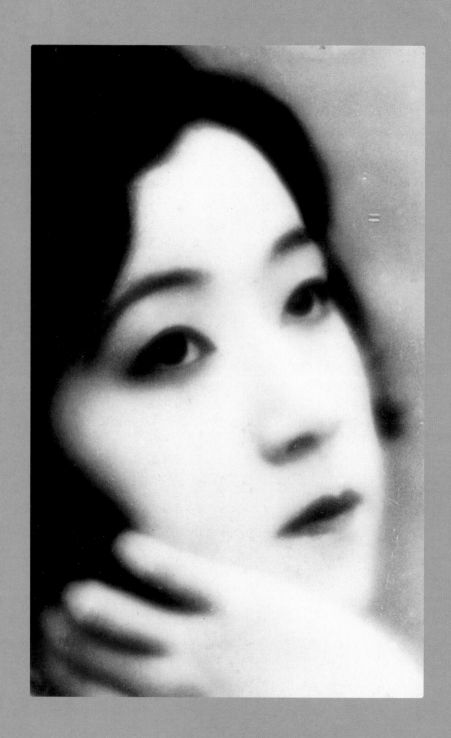

PORTRAITS

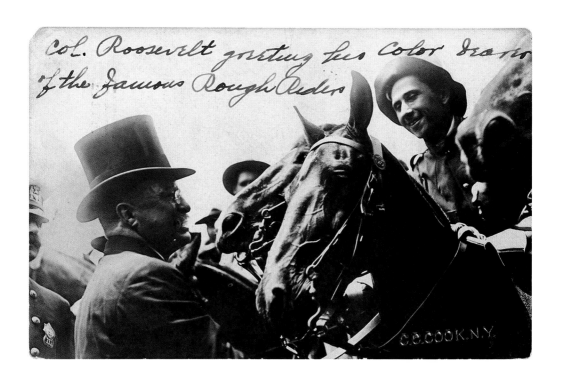

Col. Roosevelt greeting his Color [Bearer?] of the famous Rough Riders

C.C.COOK.N.Y.

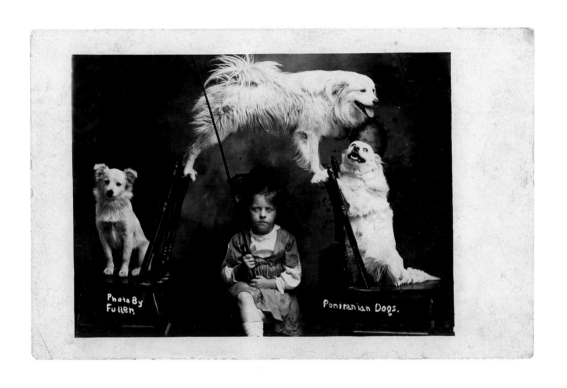

Washingtonvill, Bellmyer's Park,
from Willbur Lockard
August 31, 1908

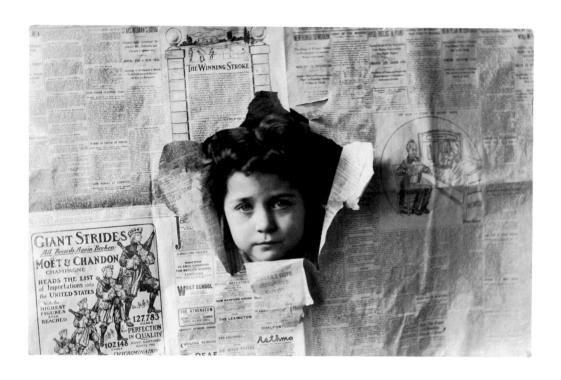

POSTMARKED:

Aurora, ILL

Jul 31, 1909 11.30 A.

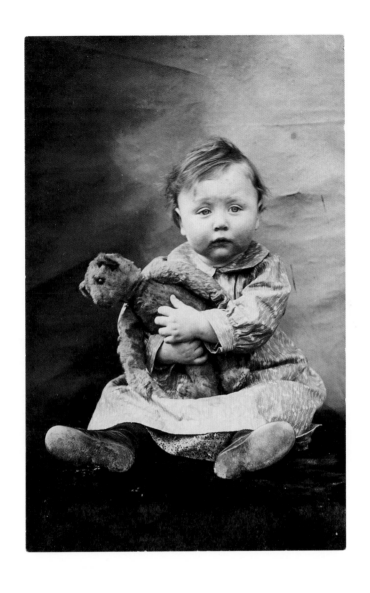

For Sylvia, age 16 mo.

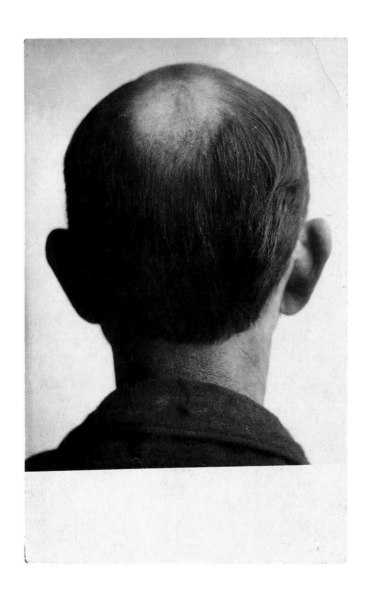

HANDWRITTEN:

I will meet you face to face tomorrow.

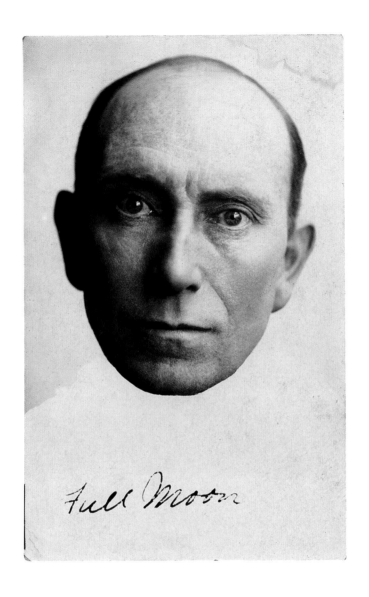

DALTON
APR
6
11 AM
1908
OHIO

HANDWRITTEN:

I told you I would meet you face to face
and here I am.

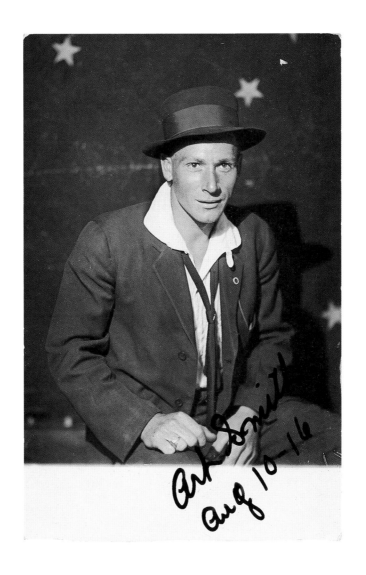

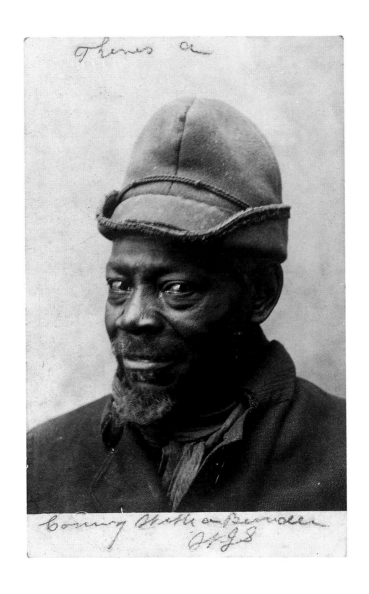

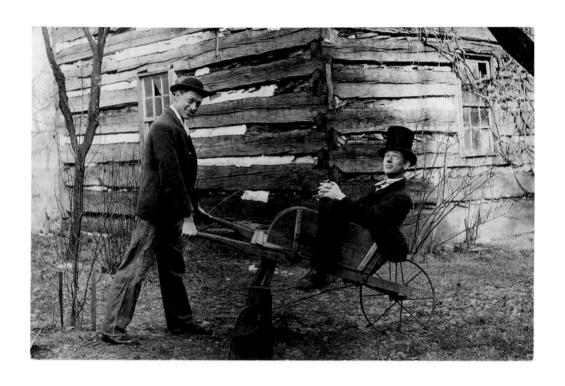

HANDWRITTEN:

Frank Burger

COLLECTOR'S NOTE:

Double self-portrait

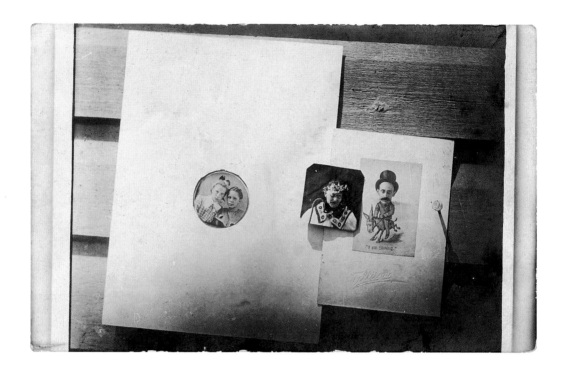

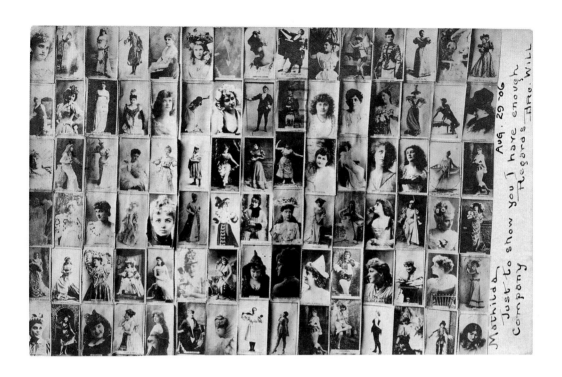

Mathilda
Just to show you I have enough
Company — Regards — Bro. Will
Aug. 29 -06

HANDWRITTEN:
Composite of cartes de visite

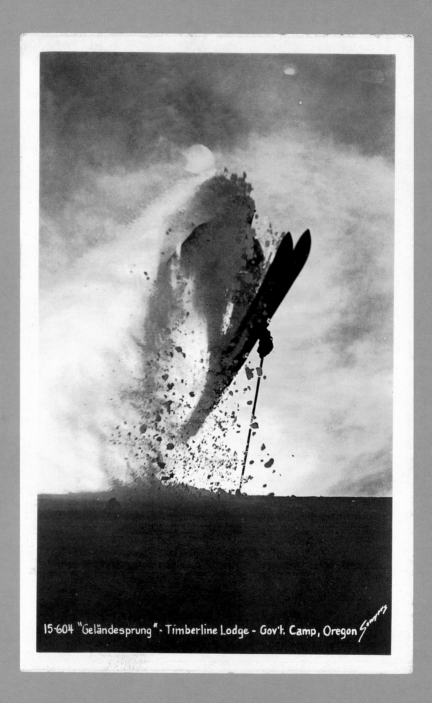

15-604 "Geländesprung" - Timberline Lodge - Gov't. Camp, Oregon

MOTION & MACHINES

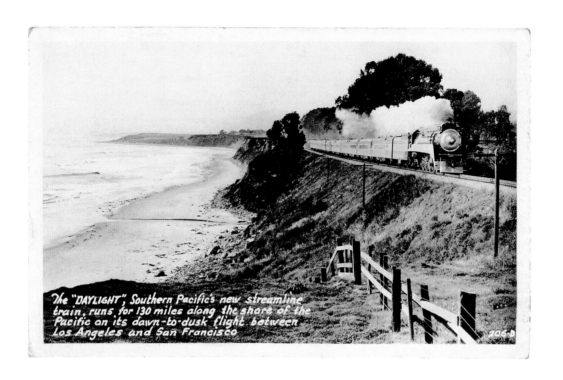

The "DAYLIGHT", Southern Pacific's new streamline train, runs for 130 miles along the shore of the Pacific on its dawn-to-dusk flight between Los Angeles and San Francisco

206-D

HANDWRITTEN:

The train we went down on, running 500 miles in 9¾ hr. a real luxury train.

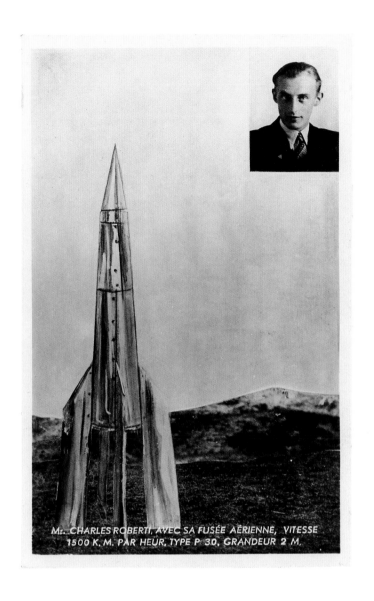

Mr. CHARLES ROBERTI, AVEC SA FUSÉE AÉRIENNE, VITESSE 1500 K. M. PAR HEUR, TYPE P 30, GRANDEUR 2 M.

STAMPED:

ALBERT PLAGE – le 4 JUIN 1936.
CETTE CARTE A ÉTÉ ENVOYÉE
PAR LA FUSÉE AÉRIENNE
"BARBARA" (Belgium)
CHARLES ROBERTI

TRANSLATION:

Postcard sent "by rocket"

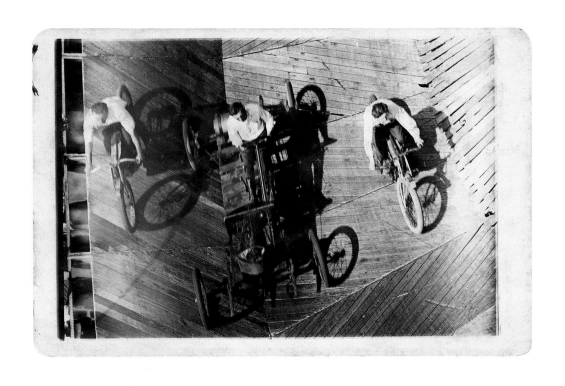

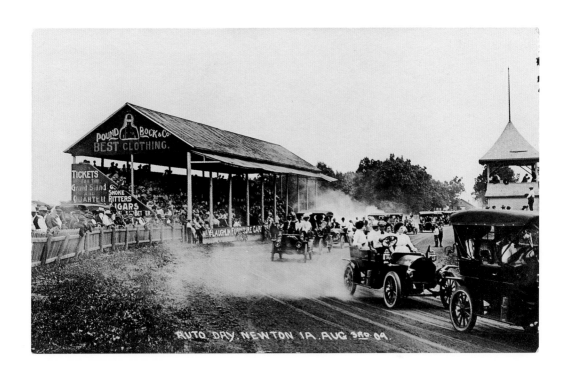

HANDWRITTEN:

8-31-09

Got home all O.K. and had to sing four songs
at the Electric Theatre the same evening—
I was scared some!
I haven't had a "scrap" since I got home.
Don't forget what I said for you to write.
(will try and write more next time.)
L.L.

STAMPED:

Published by Fay McFadden

COLLECTOR'S NOTE:

Photomontage

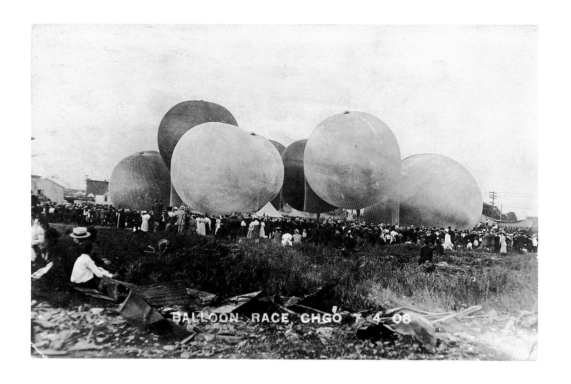

Chicago July 22/08
any time the fish want me let me know
and I will take one of these and come.
there was 9 in all went up.
Chas. 7D.

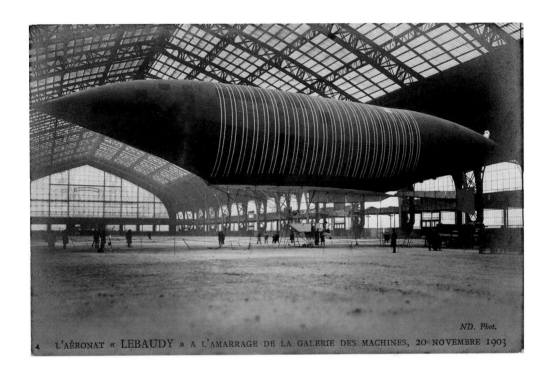

4 L'AÉRONAT « LEBAUDY » A L'AMARRAGE DE LA GALERIE DES MACHINES, 20 NOVEMBRE 1903

PRINTED:

Etablissements Photographiques
de NEURDEIN Frères. — Paris

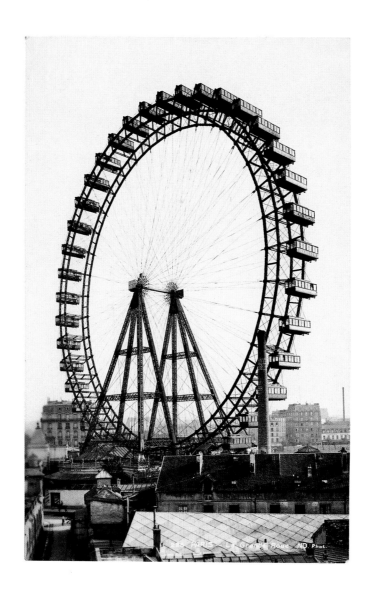

PARIS - La Grande Roue ND Phot.

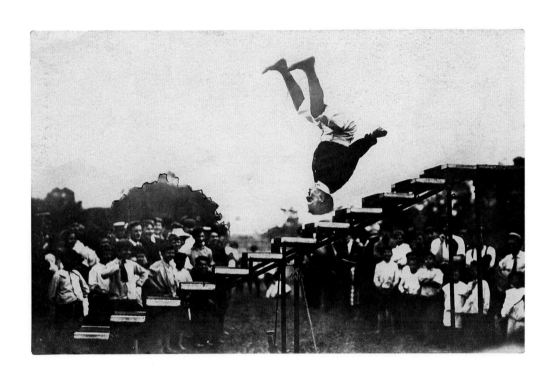

WHEELING W.VA
MAY 22
3 30 PM
1910

HANDWRITTEN:
Ringling Circus,
Pittsburg, PA (East Liberty)
PRINTED:
Garrawyas Ltd
1495 Broadway, N.Y.

TRANSLATION FROM FRENCH:
I am really surprised you did not come to see us.
We were in your city for a couple of days and
we only saw you for 2 minutes. When will
we see you now? My Compliments Alexandre Patty
ADDRESSED TO:
Monsieur Nothhelfer
Chef de Cuisine
Cincinnati, Ohio Hotel Sinton

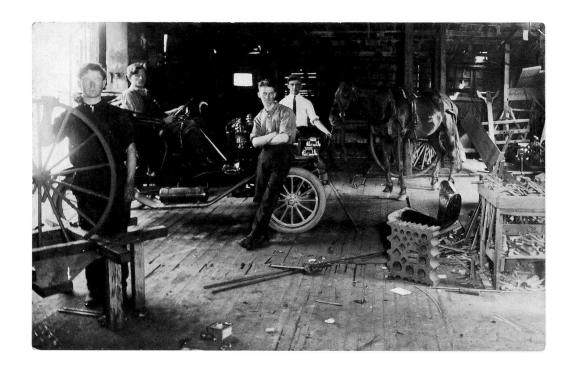

COLLECTOR'S NOTE:
Face to face, the old and the new means of transport:
from blacksmith to auto mechanic

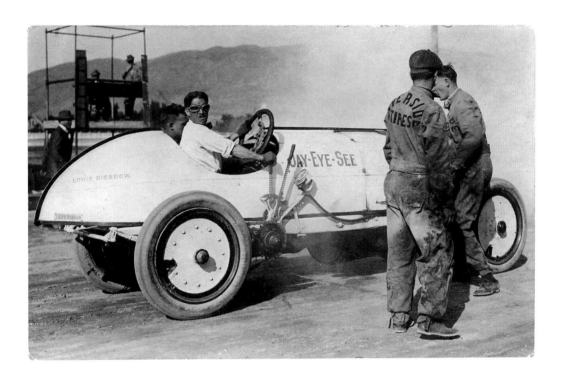

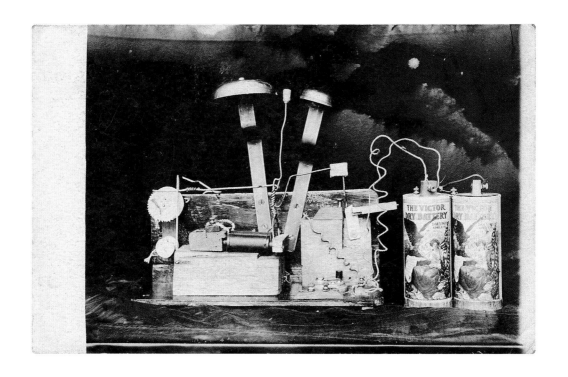

LEONARDSBURG
OHIO
MAR
25
1912

HANDWRITTEN:

If you haven't got that book yet at all you may
take it out of the library for next Sunday if you want
to but don't go to any extra trouble for me.
Dear Francis:
It was so stormy yesterday that we were not able to
come in. I thot [sic] I had better write and tell you not
to keep "Barbara Worth" out of the library overtime
for me. I will get it again sometime as soon as I can
and read it then.

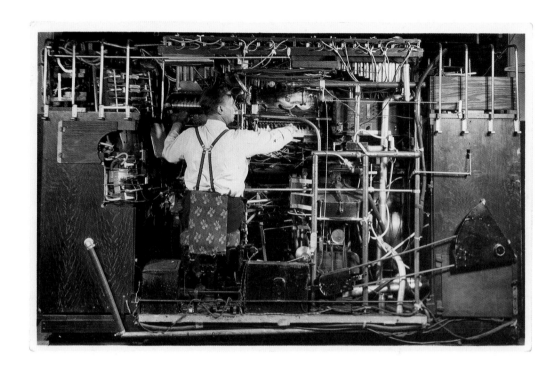

Nelson's 32 piece one man band, took 35 years to build, has 6,000 ft of rubber tubing, 50,000 parts, weighing 2,800 lbs.
Albert Nelson, Buffalo, NY

HANDWRITTEN:

Dear Mary,

See what we have to cope with out here
(see picture on opposite side). Will
write later and tell you about M + T.
Hope you are well.

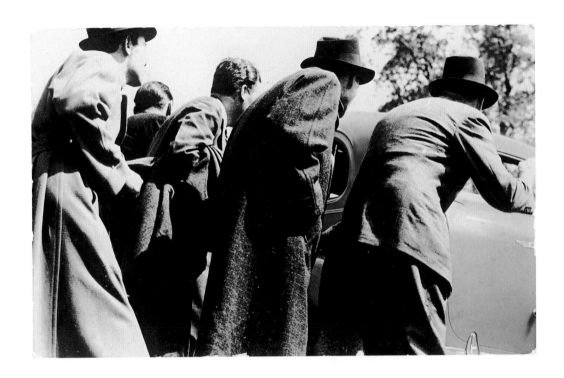

DETROIT MICH. 9
OCT 8
4 – PM
1936

Milford, Mich., Oct. 7, 1936
Just drove the new 1937 Chevrolet today!
Talk about value—the whole country will rave
about it! Wait till <u>you</u> drive this new Chevrolet.
You'll rave about its performance too.

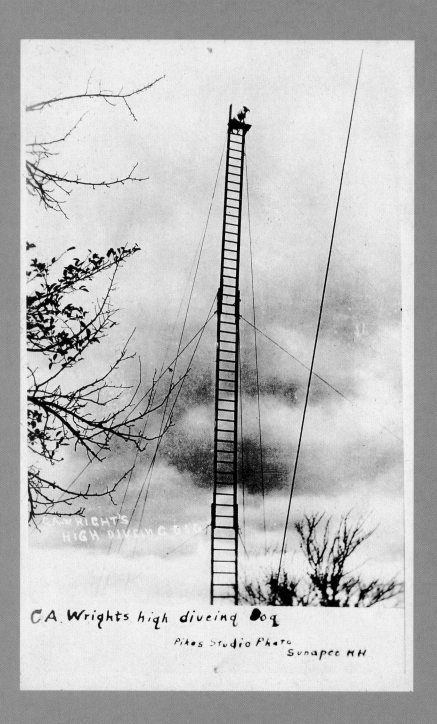

C.A. Wrights high diveing Dog

Pikes Studio Photo
Sunapee NH

GEOMETRIES

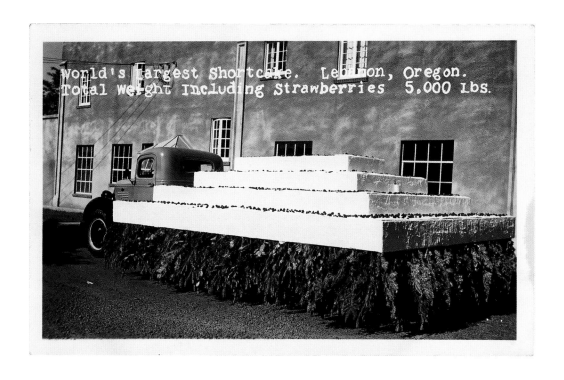

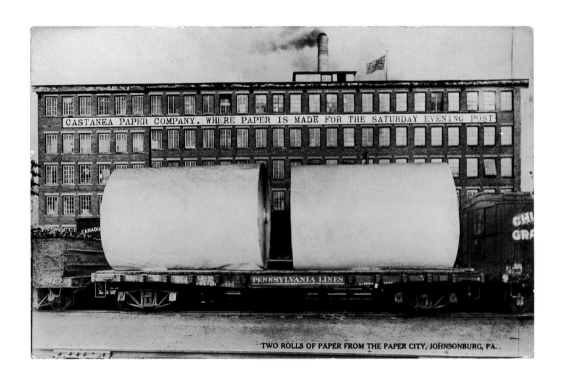

CASTANEA PAPER COMPANY. WHERE PAPER IS MADE FOR THE SATURDAY EVENING POST

TWO ROLLS OF PAPER FROM THE PAPER CITY, JOHNSONBURG, PA.

COLLECTOR'S NOTE:

Photomontage, exaggeration card

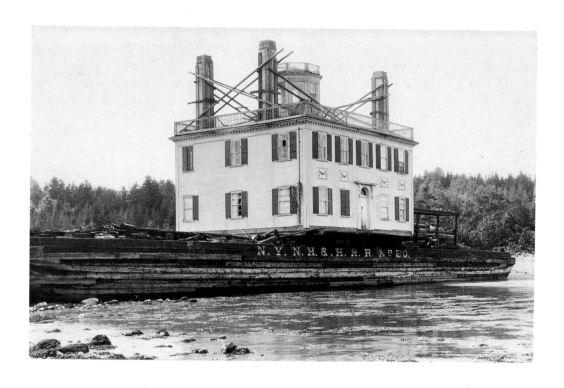

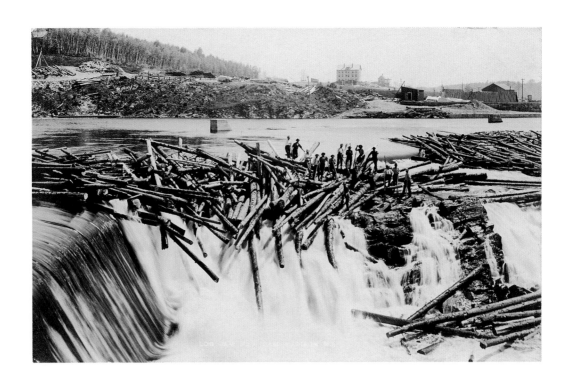

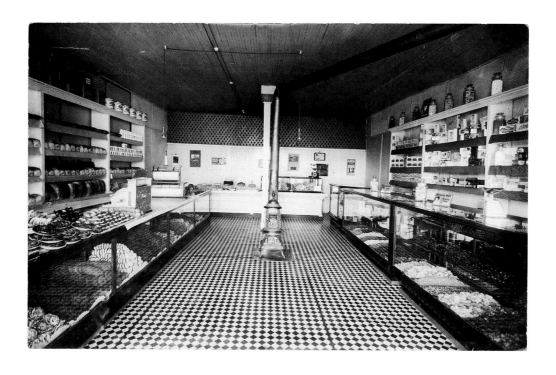

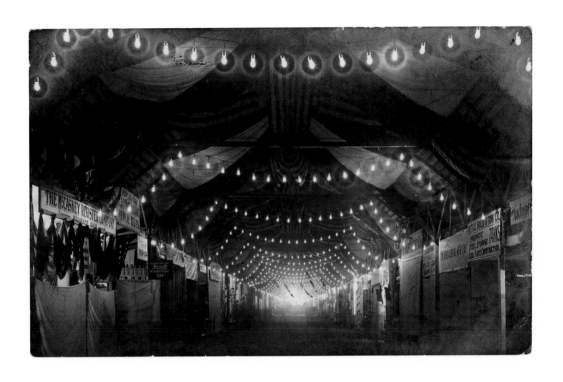

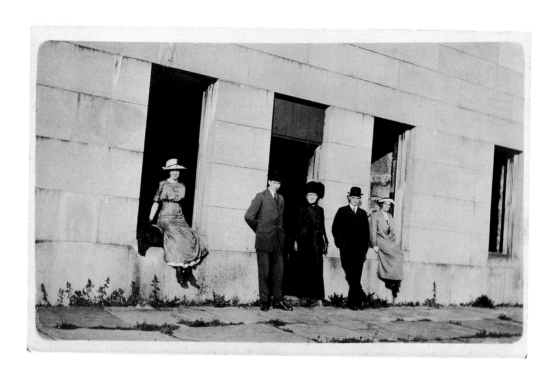

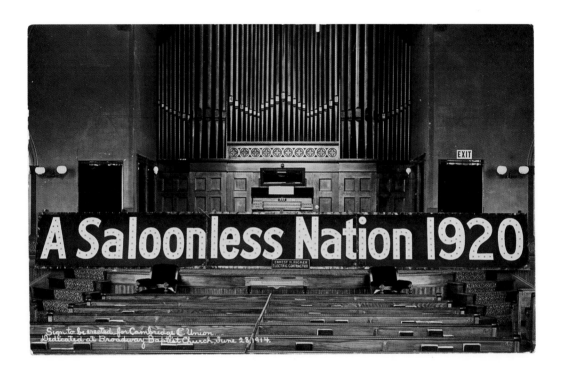

Sign to be erected for Cambridge E. Union.
Dedicated at Broadway Baptist Church, June 28, 1914.

BUFFALO
DEC 30
11 PM
1915
N.Y.

PRINTED:

Pub. By Herbert W. Glasier & Co.,
Boston, Mass.

HANDWRITTEN:

My dear Friends,
No, I have not forgotten you & the very pleasant
times associated with you. I want to wish you
"& Co." the happiest of new years. I have a new
year's card, but am sending this just to recall
the hard work, but satisfaction in connection with
the erection of this sign. most sincerely
Erving M Young
759 Ashland line Buffalo, N.Y.

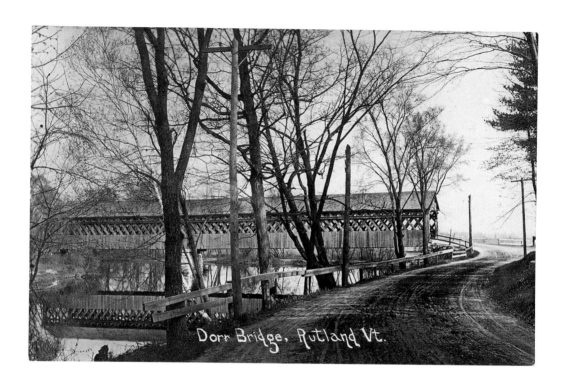

Dorr Bridge, Rutland Vt.

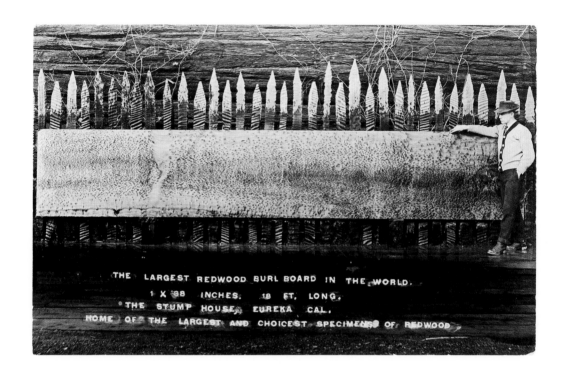

H.E. ZIMMERMAN Mt. Morris, Ill. U.S.A.

H.E. Zimmerman
4553 Walnut
Kansas City, Mo.

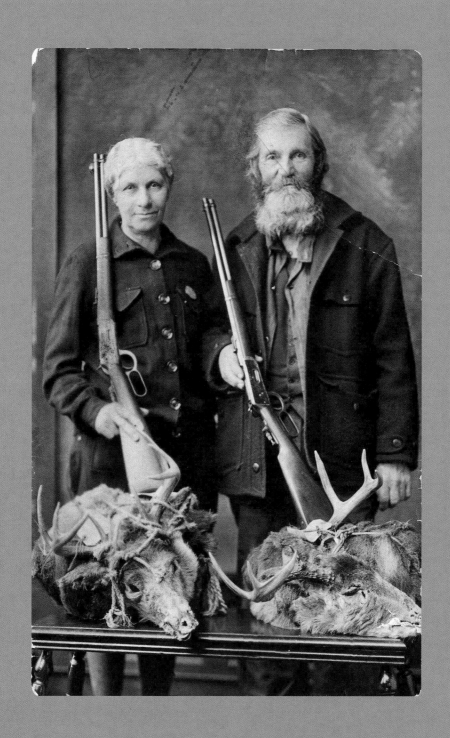

CATCH & KILL

◂◂ *overleaf*

HANDWRITTEN:
April 16, 1932
65 years today W.E. Patterson
63 years July 11, 1932 Anna B. Patterson

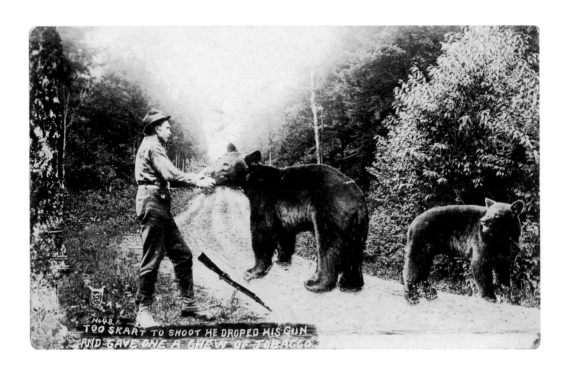

SCRATCHED ON FRONT:

Too skart to shoot he droped his gun
and gave one a chew of tobacco.

COLLECTOR'S NOTE:

Note tobacco pouch on ground behind
figure scratched into negative

PRINTED:

MADE FROM ANY PHOTO AT REMSEN, NY
BEACH'S REAL PHOTOGRAPHS
GENUINE HAND-FINISHED

HANDWRITTEN:

the expectation is great
Your Risful
Jrs S. Muir

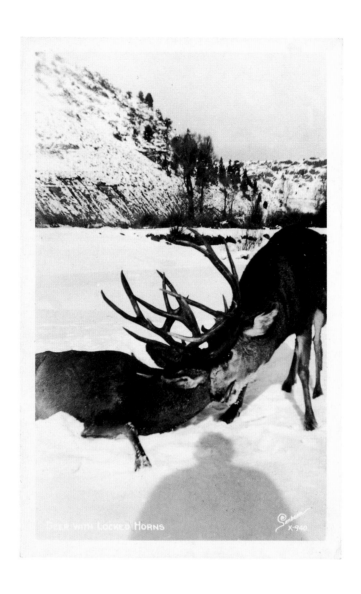

DEER WITH LOCKED HORNS

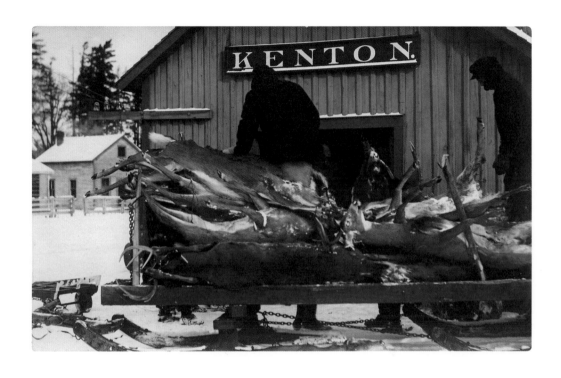

Give one of these to Earl
and one to Birt

Kenton, Michigan

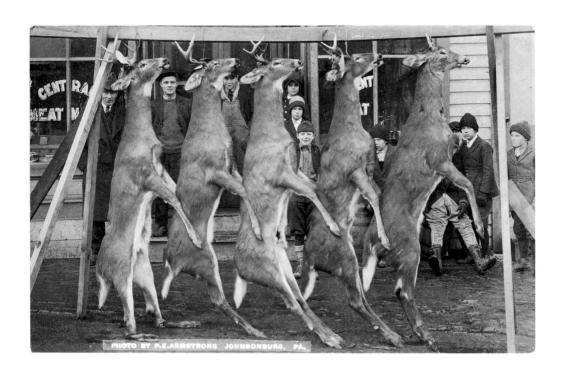

PHOTO BY P.E.ARMSTRONG JOHNSONBURG, PA.

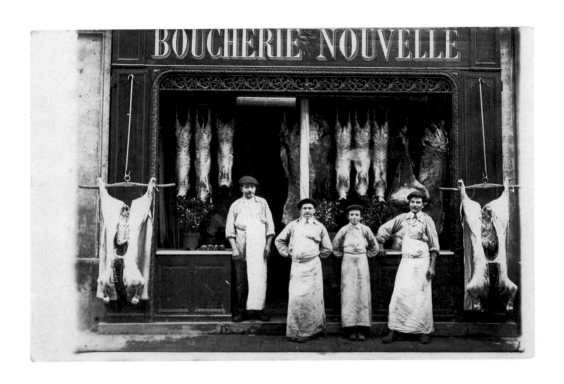

PRINTED:

Papiers Photographiques
R. DUVAU.
Colombes (France)

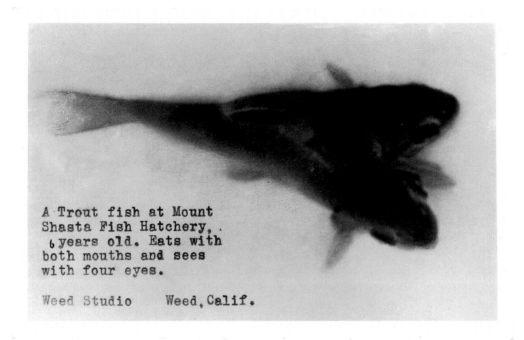

A Trout fish at Mount
Shasta Fish Hatchery,
6 years old. Eats with
both mouths and sees
with four eyes.

Weed Studio Weed, Calif.

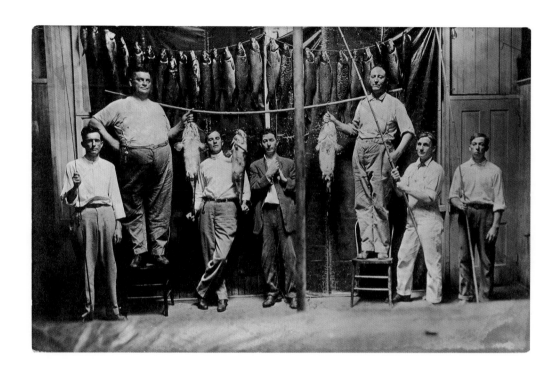

ARKANAS CITY
AUG 23
12—30 PM
KANS.

Dear Bro, This is a small catch 350lbs.
in about 3 hours, Mike.

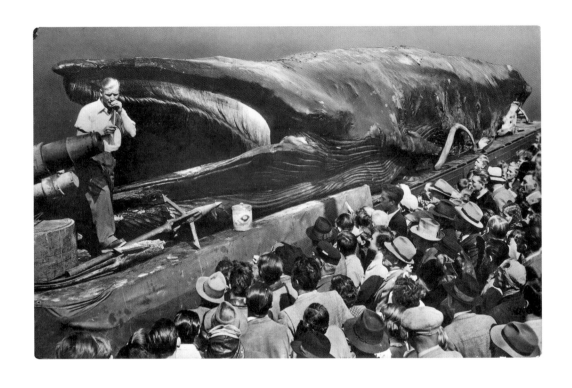

PRINTED:

GREETINGS FROM JONAH
THE GIANT WHALE

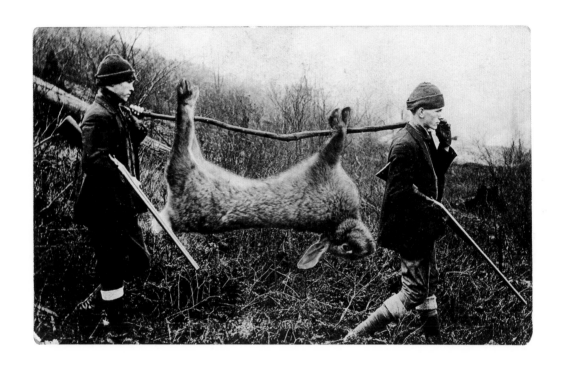

SCRATCHED ON FRONT:

Rabbit hunting in …

COLLECTOR'S NOTE:

Photomontage exaggeration card

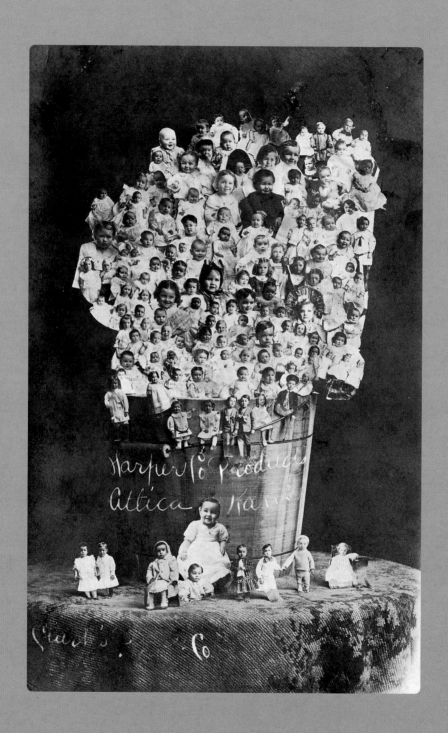

HARVEST

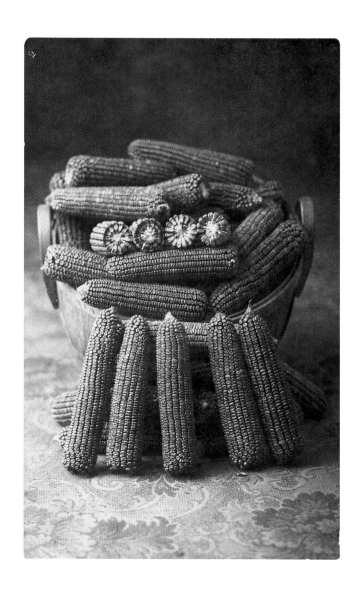

◂◂ *overleaf*

POSTMARKED:
Attica, Kans. Apr 17, 1908

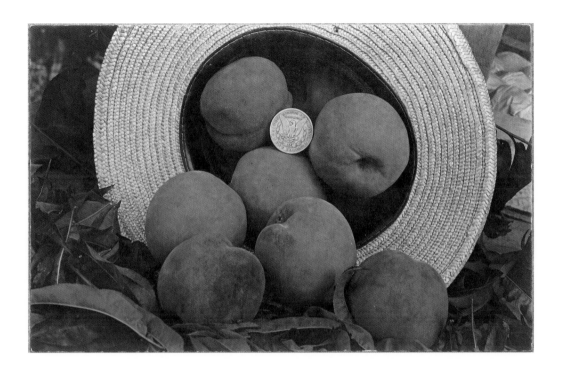

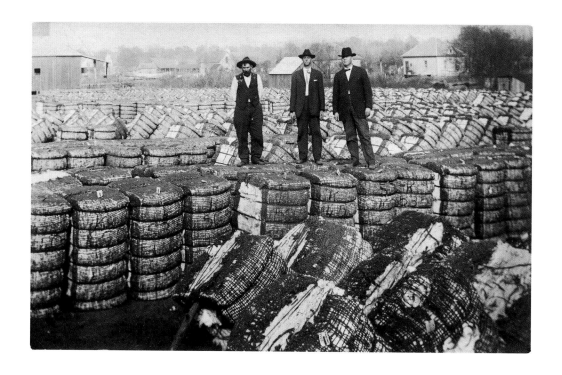

This card is from Uncle Charley so you can
have and [sic] idea how they have the cotton
piled around Briston.

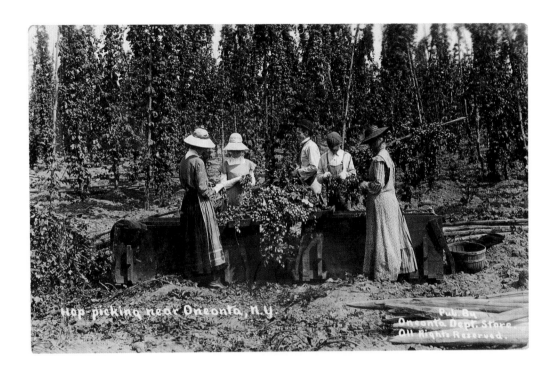

Hop-picking near Oneonta, N.Y.

Pub. By
Oneonta Dept. Store
All Rights Reserved.

HANDWRITTEN:

That card is the one I have wanted for a long time.
We have sent out all the views of our house but I will
send one later. I have just got home from a short
vacation. I have picked hops every year since I was
9 years old. The same T.L.B. Feb 6, 1911.

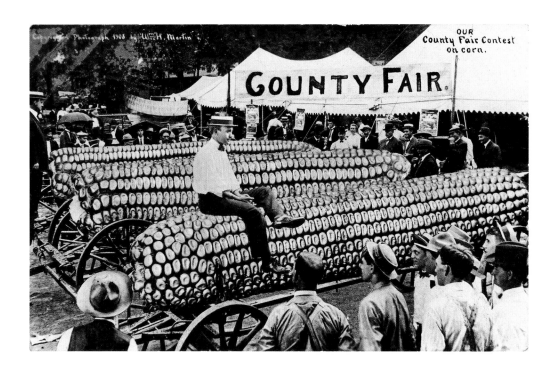

COLLECTOR'S NOTE:

Photomontage exaggeration card

Photography 1908 by William H. Martin

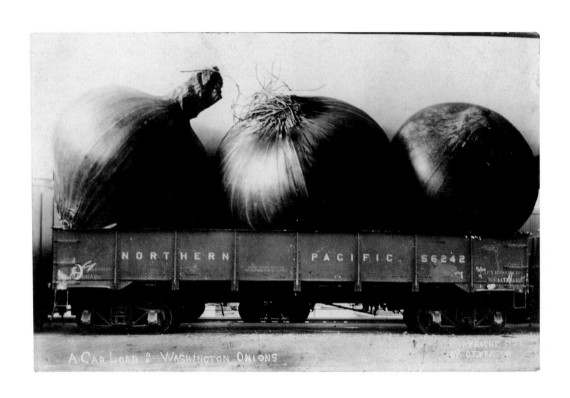

A CAR LOAD OF WASHINGTON ONIONS

SEATTLE, WASH
JUN 13
7 – PM
1910

HANDWRITTEN:

Would this make you cry? I believe Washington,
next to Oregon is the greatest state in the union.
L. Seattle

COLLECTOR'S NOTE:

Photomontage exaggeration card
Copyright O. T. Frasch 1909

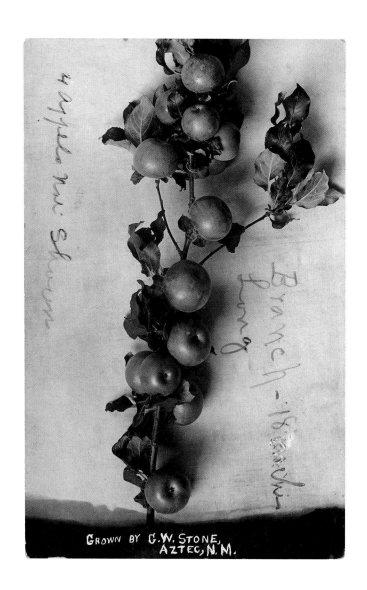

GROWN BY G.W. STONE,
AZTEC, N.M.

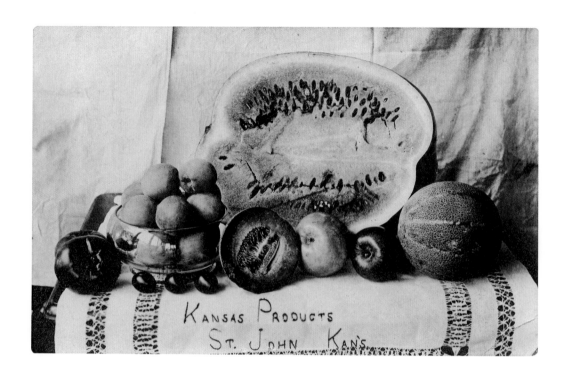

HANDWRITTEN:

10/29/08

Your card rec'd this a.m. thank [sic] always
glad to hear from you. Have you ever been
in the West? What do you think of this for
"Sunny Kansas"

Joel L.

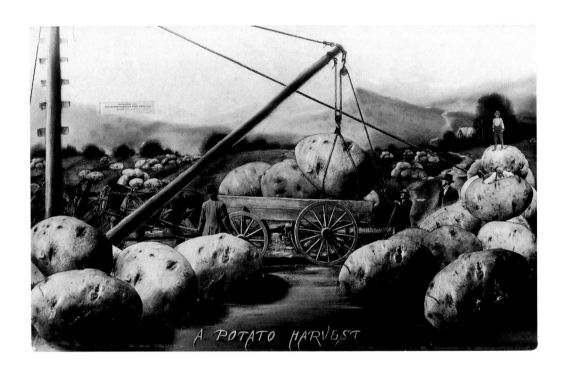

A POTATO HARVEST

PRINTED:

PUBLISHED BY
THE NORTH AMERICAN POST CARD CO.
KANSAS CITY, U.S.A.

COLLECTOR'S NOTE:

Photomontage exaggeration card

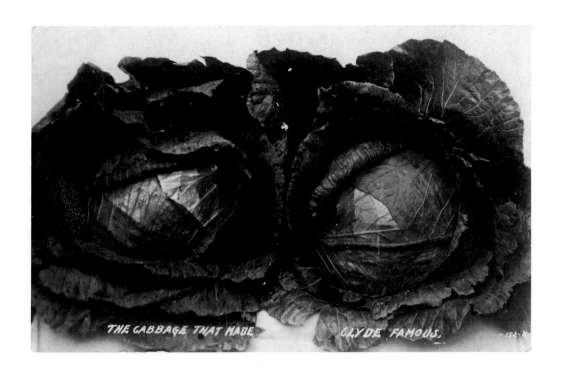

THE CABBAGE THAT MADE CLYDE FAMOUS.

PRINTED:

PHOTO BY BRYAN POST CARD CO, BRYAN, O.

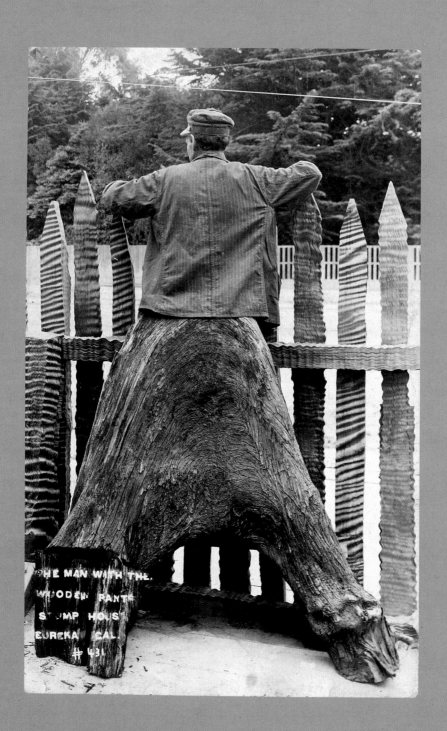

THE MAN WITH THE
WOODEN PANTS
STUMP HOUSE
EUREKA CAL.
#431

UNCANNY

◄◄ *overleaf*
POSTMARKED:
Eureka, CAL. Aug 5, 1925

TRANSLATION FROM FRENCH:

My dear Marie-Thérèse

I visited your mother and that's how I got some news about you as I had not received anything from you since you left for Francfurt. I am happy that you are content, and I'd love to see you again, but alas ... I still have not found a man, I work a bit at home and at the store. I am about to forget all the German I knew. You continue to work like an angel. I send you thousand kisses. Excuse my scribbling, I am writing at the post office, with a nail. Juliette

ADDRESSED TO:

Fraulein M. Thérèse Lemaire
Bei M. Rau-Cuers
61 V Weserstrasse
Francfurt am Main
Allemagne
(1911)

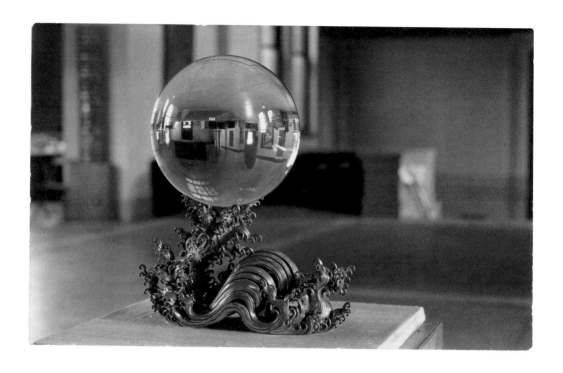

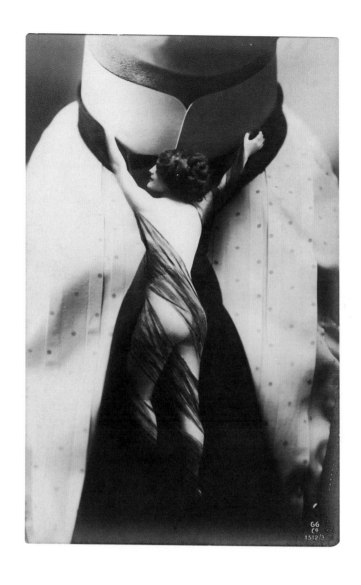

COLLECTOR'S NOTE:
"Femme Cravate,"
Surrealist photomontage
(#3 of a series of 10; in each card the position
of the female figure changes slightly)

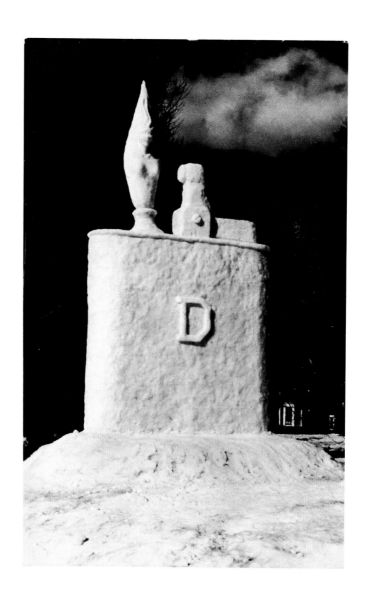

COLLECTOR'S NOTE:
Notice female torso in flame. Location
possibly Dartmouth College, a student
snow sculpture

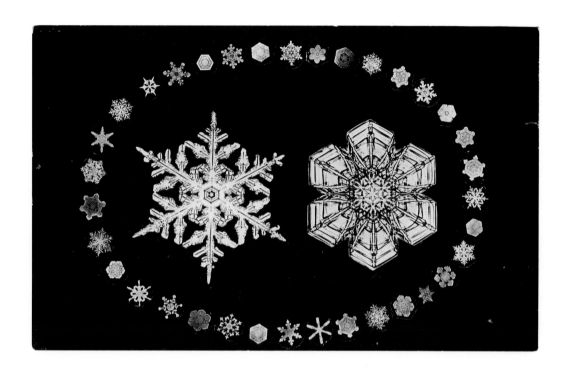

COLLECTOR'S NOTE:

Montage of various photomicrographs of
snow crystals made by Wilson "Snowflake"
Bentley (1865–1931) in Vermont

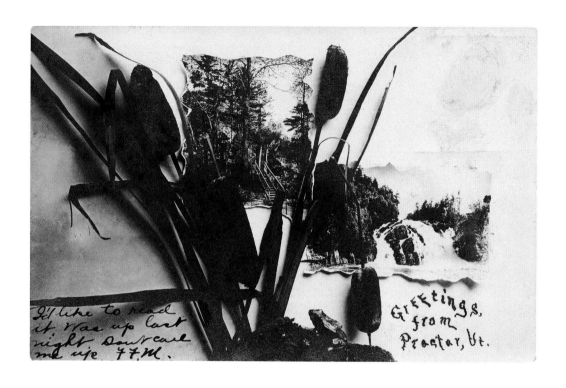

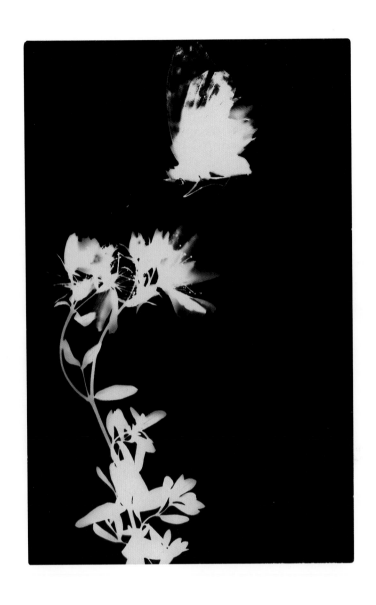

COLLECTOR'S NOTE:

Photogram; probably European

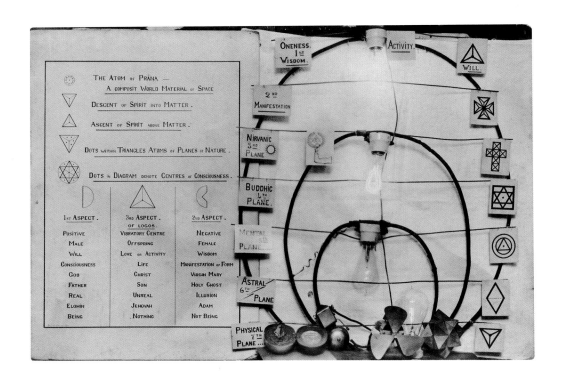

Demonstrations of spiritual planes

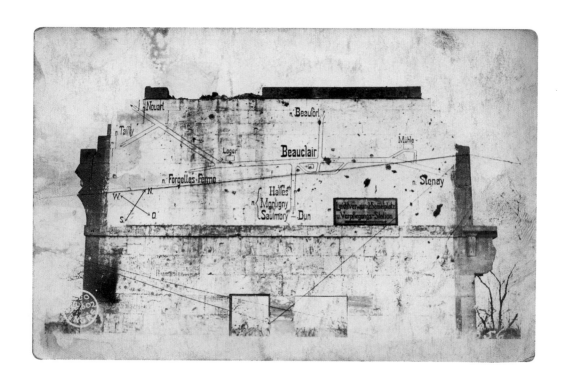

Beauclair map of routes, painted on side
of war-damaged structure.

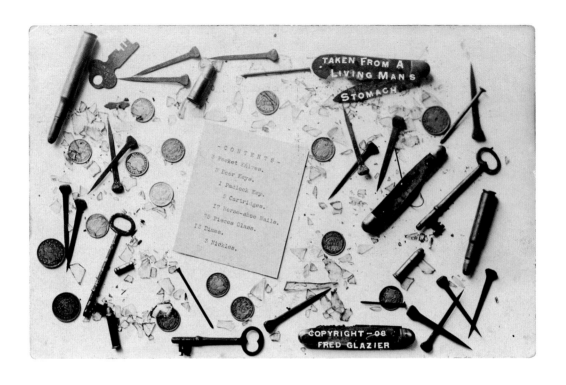

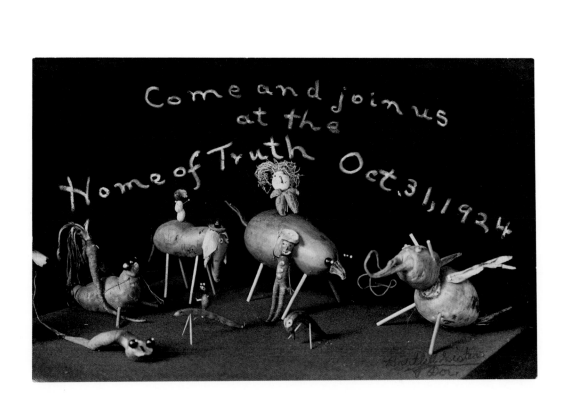

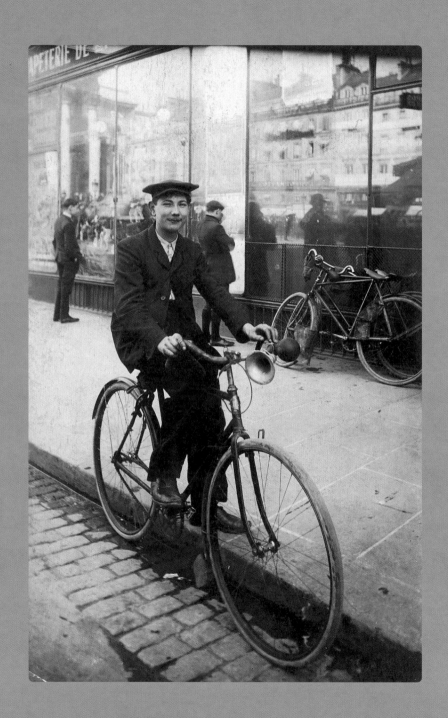

MAIN STREET

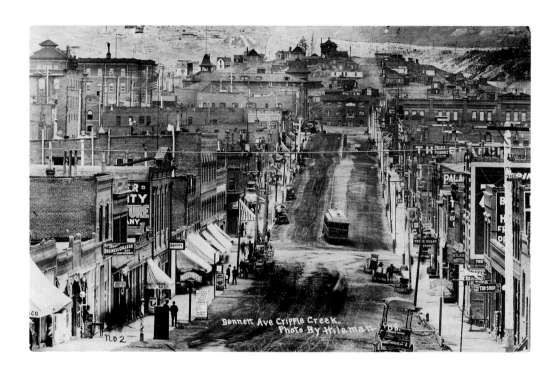

Bennett Ave Cripple Creek.
Photo By Hileman '08.

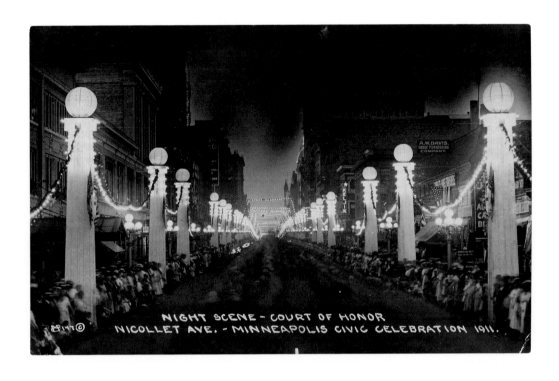

NIGHT SCENE - COURT OF HONOR
NICOLLET AVE. - MINNEAPOLIS CIVIC CELEBRATION 1911.

DESCRIPTION:
Advertising card for
Northwest Electrical Company

PRINTED IN RED INK:
Northwest Electrical Company—
Civic Celebration Decorators
7 North 3rd Street

HANDWRITTEN:
This celebration lasted a [sic] the week
of the 4th. All well here hope you are
write soon Gene.

ORDRE
A LA POPULATION LIÉGEOISE

La population d'Andenne, après avoir témoigné des intentions pacifiques à l'égard de nos troupes, les a attaquées de la façon la plus traîtresse. Avec mon autorisation, le général qui commandait ces troupes a mis la ville en cendres et a fait fusiller **110** personnes.

Je porte ce fait à la connaissance de la Ville de Liége pour que ses habitants sachent à quel sort ils peuvent s'attendre s'ils prennent une attitude semblable.

Liége, le 22 Août 1914.

Général von BULOW.

TRANSLATION:

Warning to the population of Liège (Belgium)
The Population of Andenne after having been shown peaceful intentions towards our troops has attacked them in the most trecherous fashion. With my authorization, the general in charge of these troops has burned the town, and shot 110 people.
I inform the City of Liège so that its inhabitants know what awaits them should they act similarly.
August 22, 1914
General von BULOW

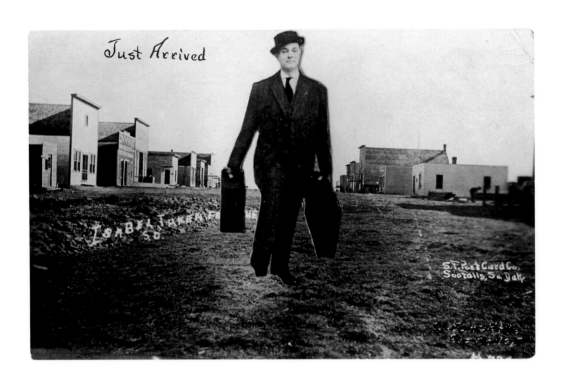

Just Arrived

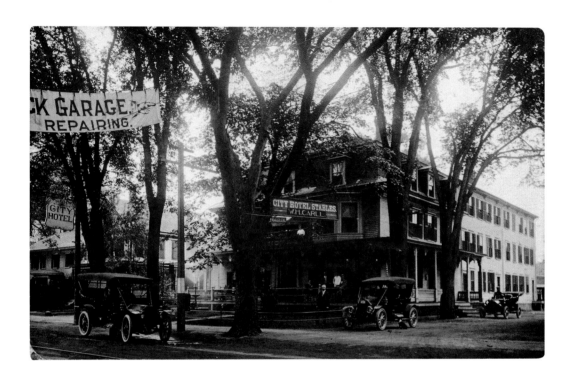

Colebrook—Friday.

I have been sick.

Will try & write you soon.

Did you get my last letter?

Much love—

Willie L

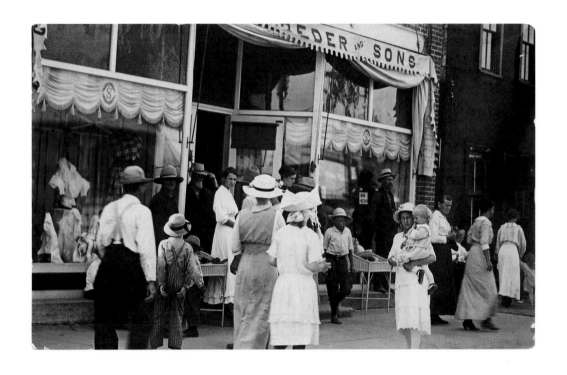

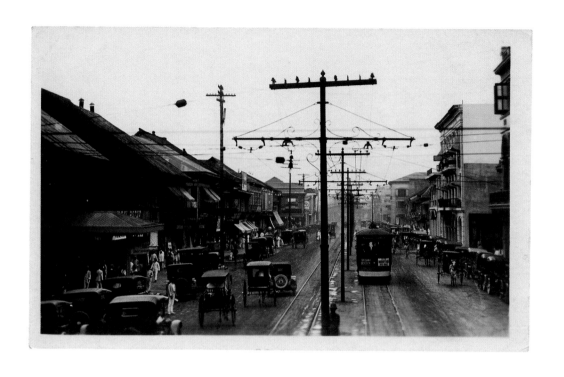

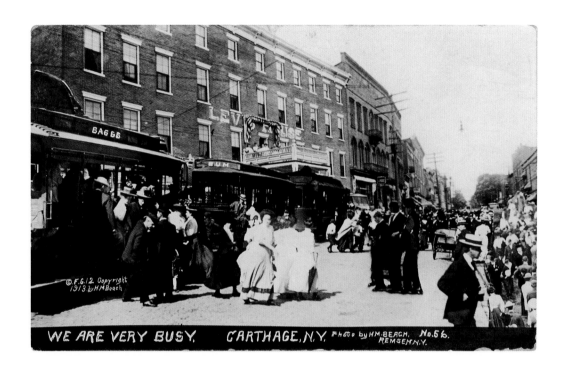

WE ARE VERY BUSY. CARTHAGE, N.Y. *Photo by H.M.BEACH. No.56.*
 REMSEN.N.Y.

PRINTED:
MADE FROM ANY PHOTO AT REMSEN, NY
BEACH'S REAL PHOTOGRAPHS
GENUINE HAND-FINISHED

DEALER'S NOTE:
Photomontage of Main Street; streetcars,
three men right of center, and crowd on sidewalk
at right are all added to street scene

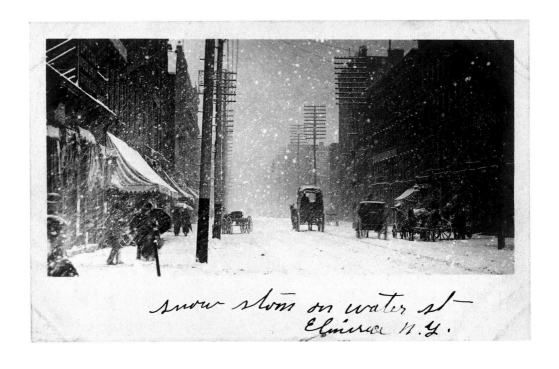

snow storm on water st — Elmira N.Y.

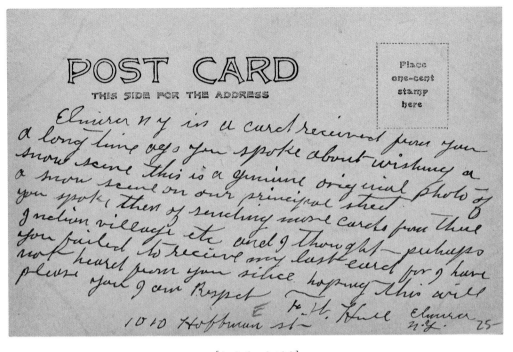

POST CARD

THIS SIDE FOR THE ADDRESS

Place
one-cent
stamp
here

Elmira N Y is a card recieved from you a long time ago you spoke about wishing a snow scene this is a genuine original photo — a snow scene on our principal street you spoke then of sending more cards from their Indian village etc and I thought — perhaps you failed to recieve my last card for I have not heard from you since hoping this will please you I am Respect

1010 Hoffman st— E. H. Hull Elmira N.Y. 25—

[back of card at left]

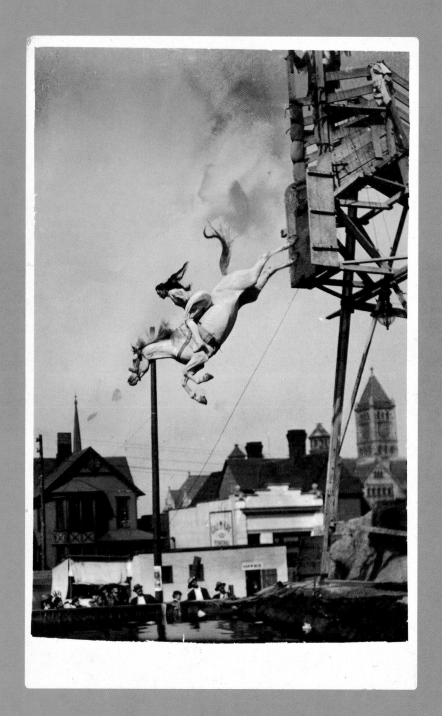

AMUSEMENTS

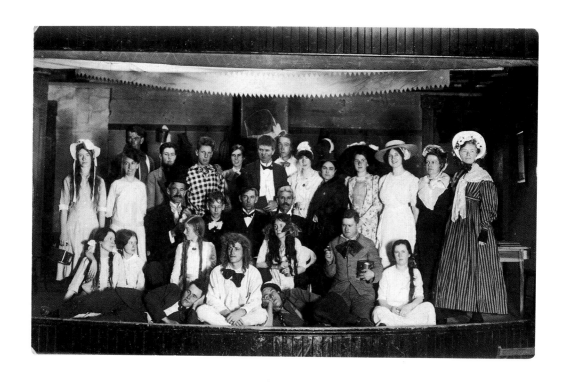

◀◀ *overleaf*
DEALER'S NOTE:
Syracuse, NY

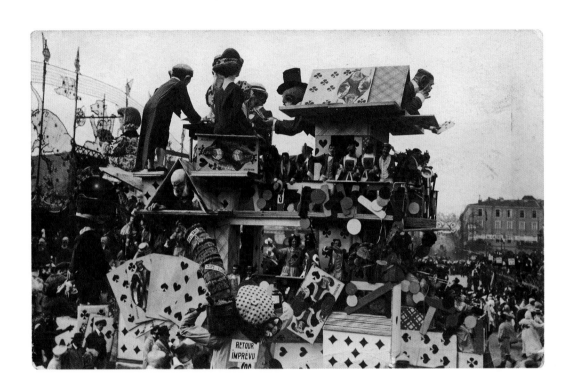

This is quite a place. Mother, Father and
I are all going to a ball Sunday night in
costumes. Can't you see us? I wish you could
see the way they dance over here!

Nice, France

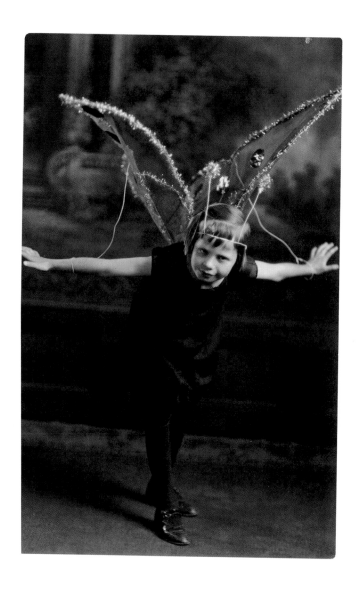

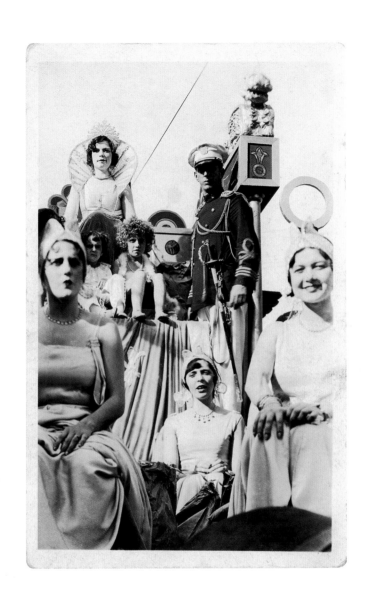

DEALER'S NOTE:

A circus float, Oldtown, ME

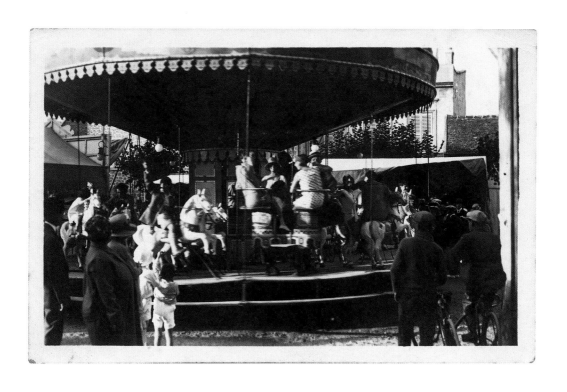

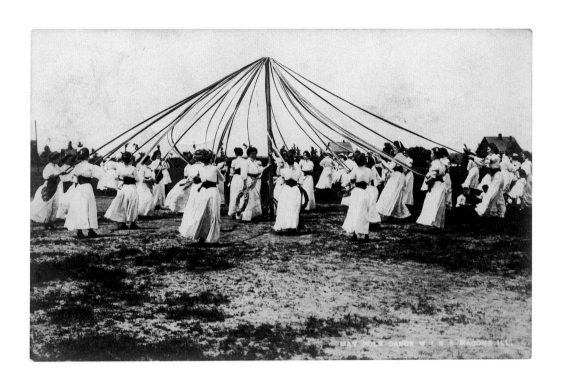

For sale by
McCLELLAN BOOKSTORE, Macomb, Ill.
HANDWRITTEN:
This card gives one of the pictures of our field day.
Hope you are fine and coming to Denmark this
summer. We are having a week of vacation.
With love Eva

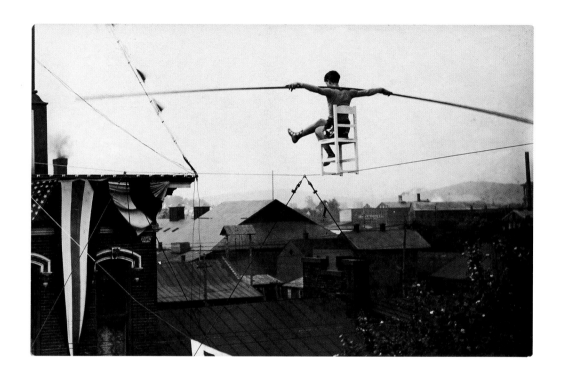

PRINTED:

Photo by Simon & Marhahe

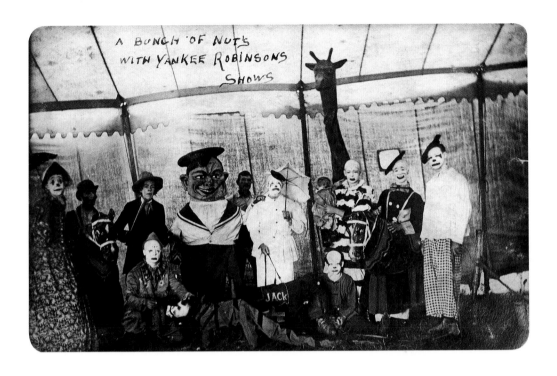

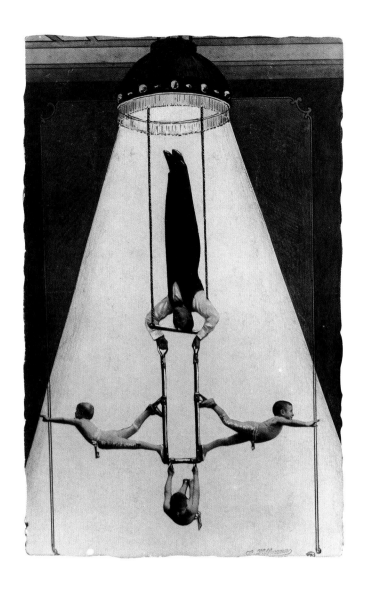

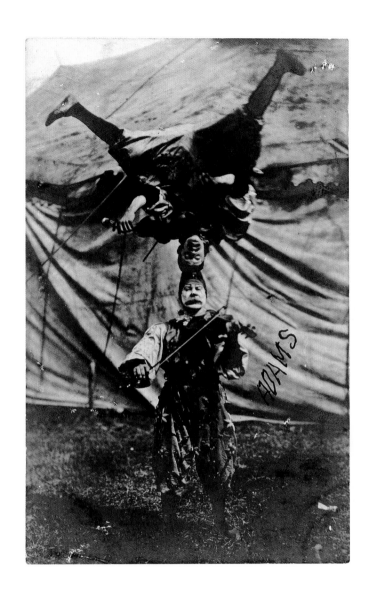

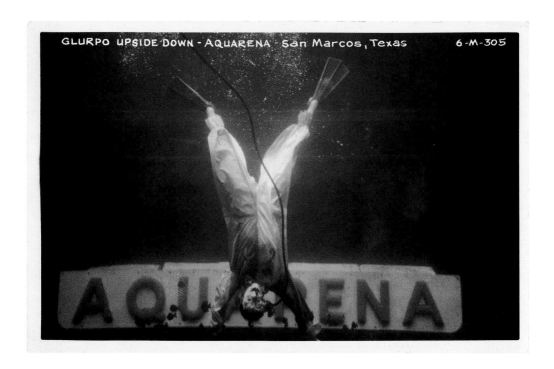

GLURPO UPSIDE DOWN - AQUARENA - San Marcos, Texas 6-M-305

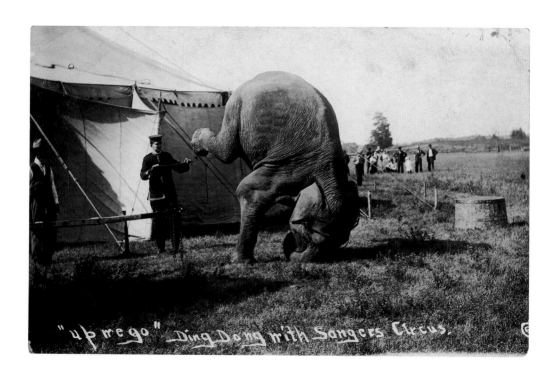

"up we go" Ding Dong with Songers Circus.

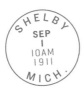

SHELBY
SEP
1
10 AM
1911
MICH.

HANDWRITTEN:

Dear Sister Your card received and they were just
dandy. Will send you a Picture of the Circus that
came to Shelby this fellow was so ashamed to
think he came to Shelby that this is what he done.
How are you? I hope you are well. I suppose Alla
will be with you folks next Monday. Would like
to be there too.
Yours with lots of love from sis
Please write soon

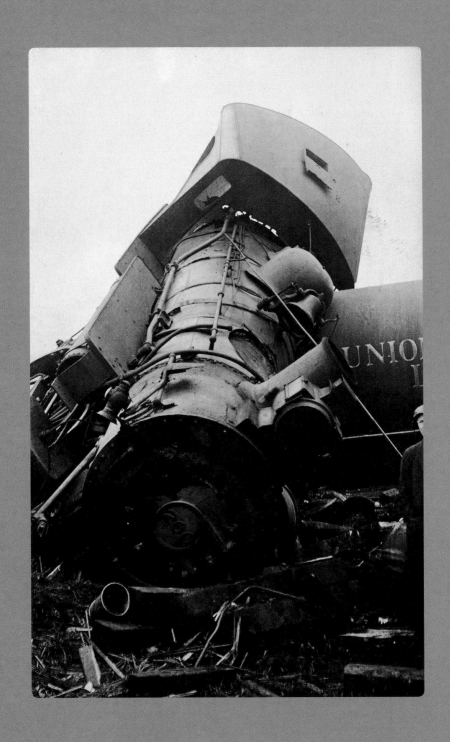

DISASTERS

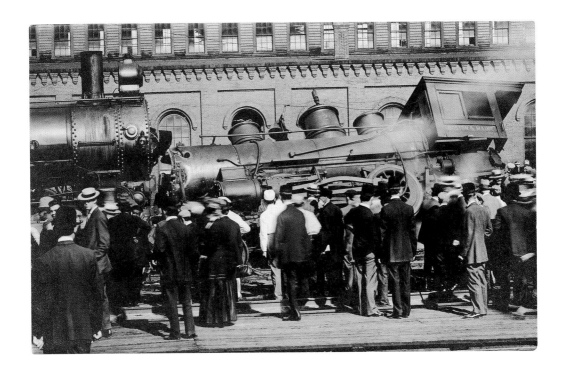

Boston & Me, R.R.

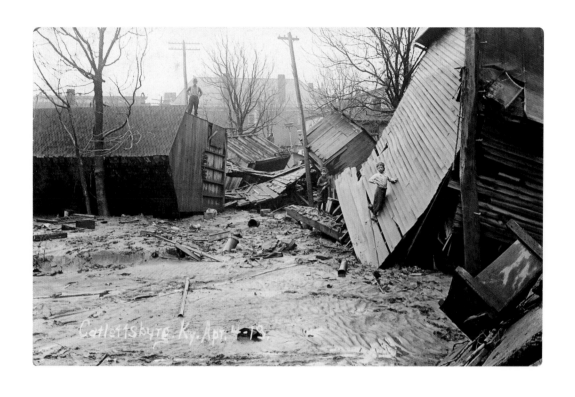

Catlettsburg, Ky. Apt. 4-19

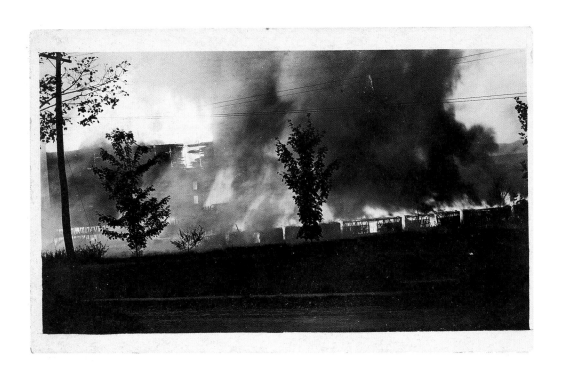

HANDWRITTEN:

Play in Richford tonight

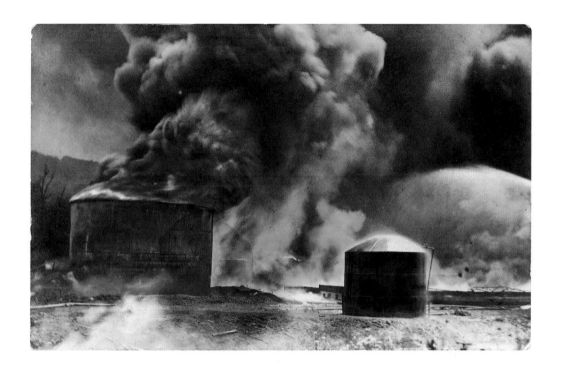

NORTH WARREN
JUL
10
8 PM
1908
PA.

HANDWRITTEN:

Dear brother,

This is where your father will start to lay brick
next week. We returned from Celeron last evening
somewhat tired but all O.K. today.

With love, Gina

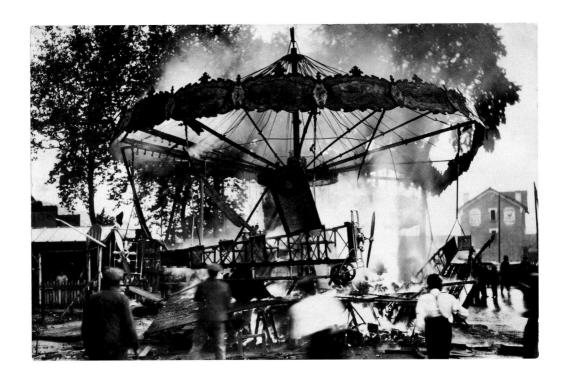

France

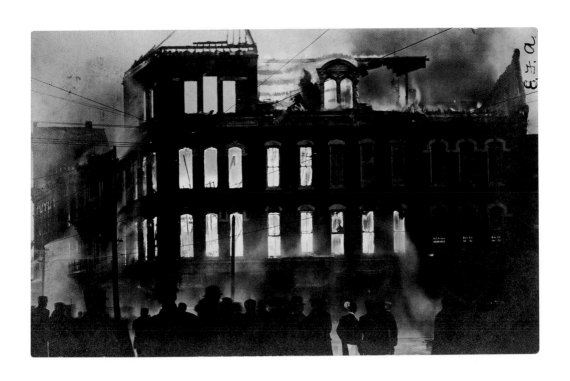

DEALER'S NOTE:
HC Farrar insurance sign
(in window of burning building)

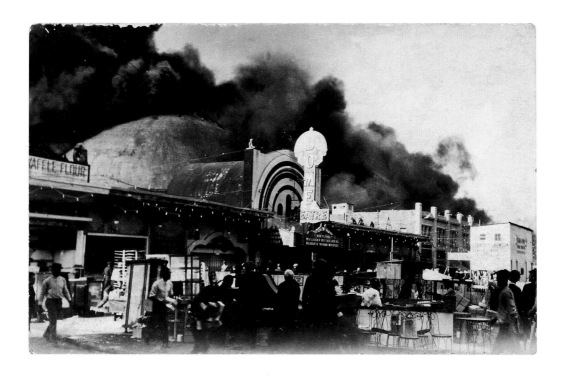

HANDWRITTEN:

This is a view of the big Ocean Park Pier fire.
Did not cross the Boardwalk and did not burn all
the pier. The Dome is asbestos and saved some
other buildings All are well & got your letter this
am of the 11th. Have written twice lately and will
write again. Came home Sun. from Hyde Park.
Had a fine time went to the Redondo Beach nearly
every day. Am looking for you folks very anxiously.
Love from Mother Kinnie
(The fire wreckage last Sun)

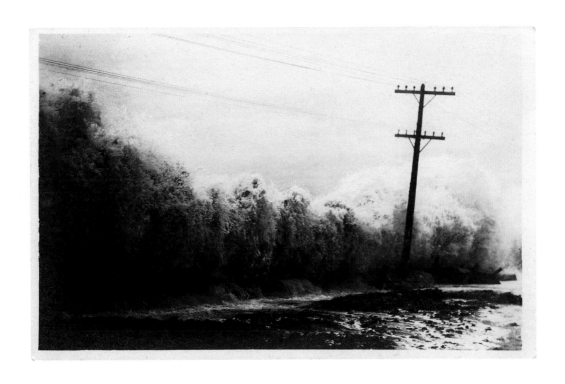

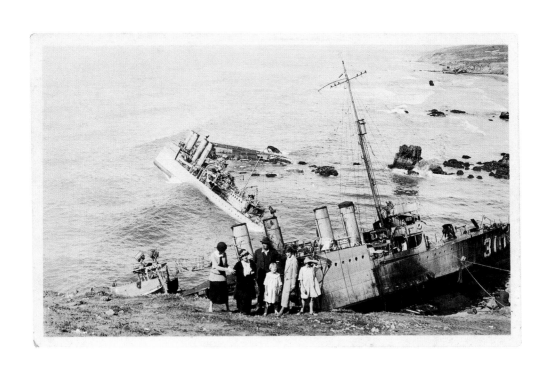

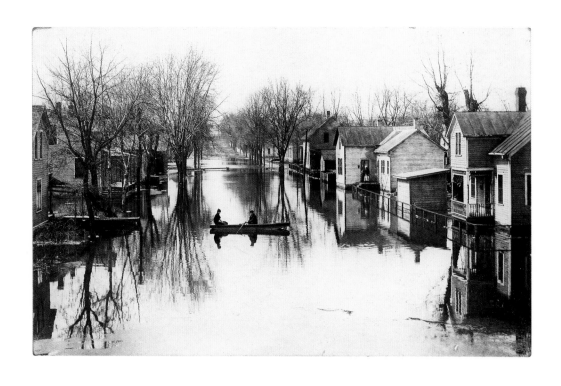

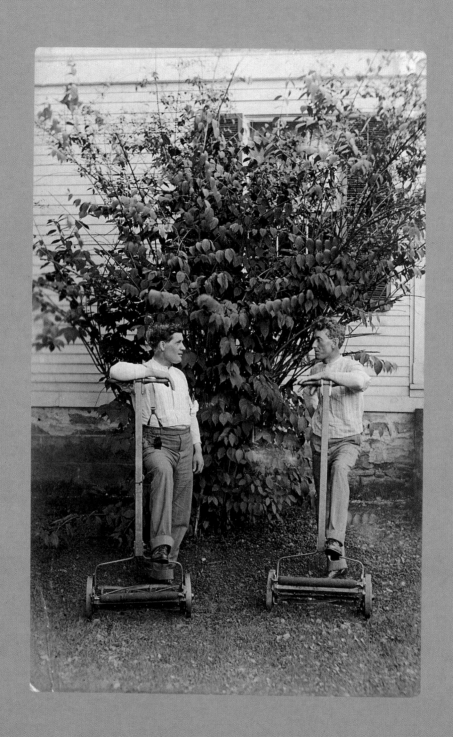

HOME SWEET HOME

◀◀ *overleaf*
POSTMARKED:
Portsville, NY Jul 30, 1910
PRINTED:
Made by Edw Everett, Shingle house, PA.

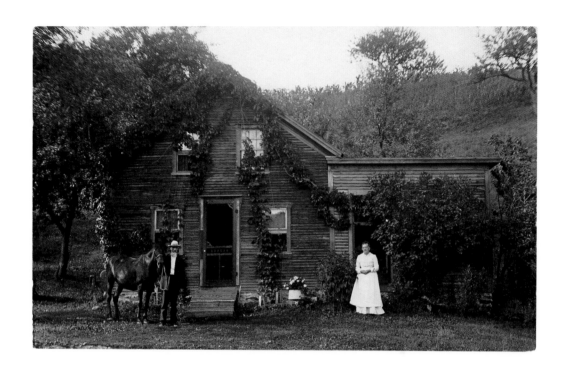

PRINTED:

Published by W.L. Glysson,
"Johnnie On The Spot"

PRINTED:

Société des Produits "As De Trèfle

COLLECTOR'S NOTE:

France

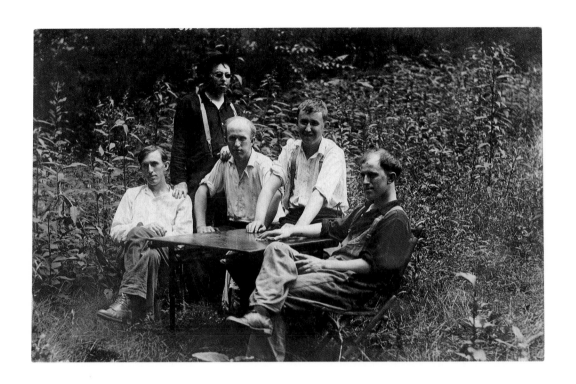

Weaver Brothers and Ray Wadell, East Sidney, A.

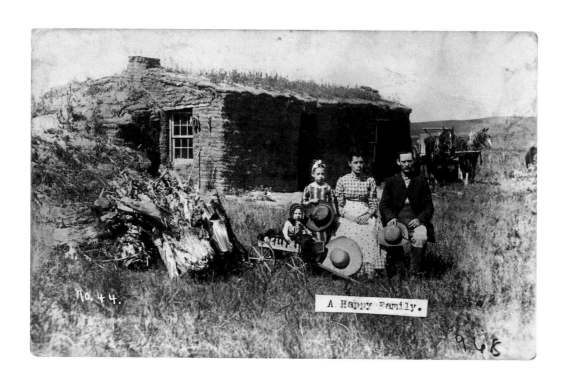

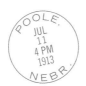

HANDWRITTEN:

Photo by S. D. Butcher

COLLECTOR'S NOTE:

Family in front of their sod house

COLLECTOR'S NOTE:

Pageant, Barton VT.
This book is dedicated to Marjorie Ward,
the young girl on the far right, who turned
99 years old on April 26, 2005.

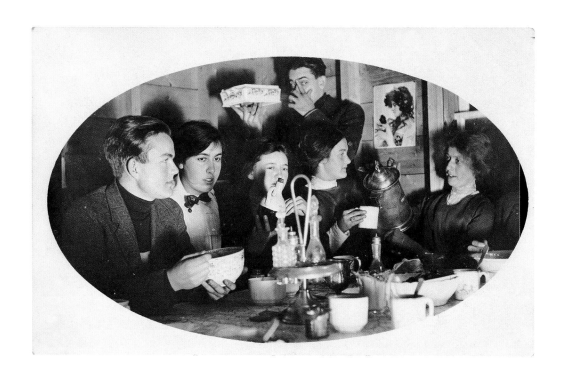

Carr's cottage, Jan 17, 1914

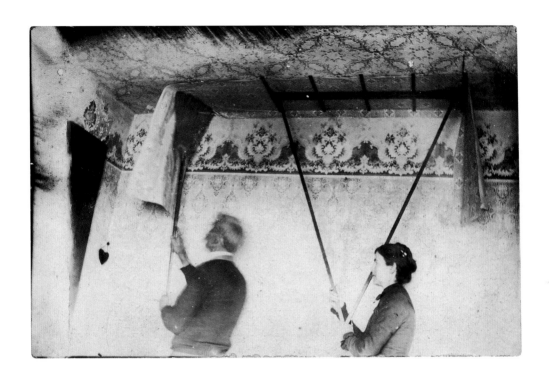

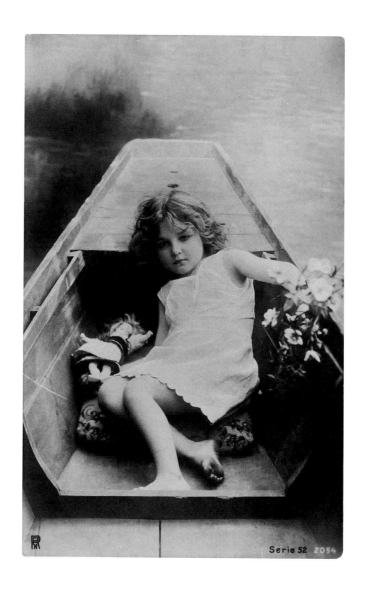

Serie 52 2054

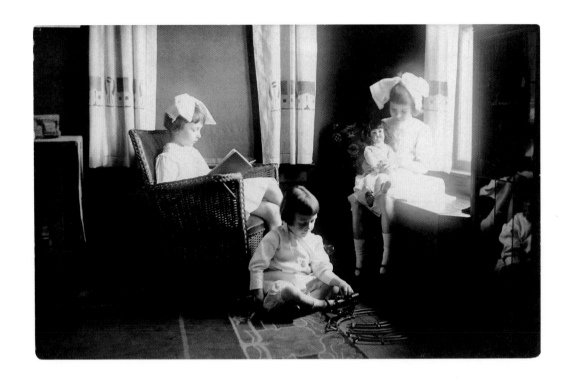

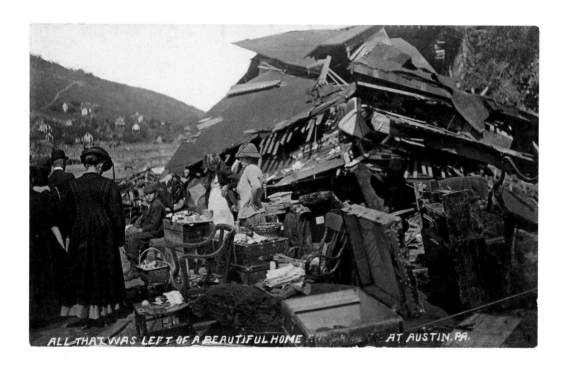

ALL THAT WAS LEFT OF A BEAUTIFUL HOME AT AUSTIN, PA.

TWENTY PHOTOGRAPHS
OF AUSTIN RUINS.
TWENTY DIFFERENT VIEWS
Price List: 500, Assorted, $15.00; 100, Assorted,
$25.00 including one mammoth Panorama of
the whole valley, showing from the dam through
devestated district distinctly. A wonderful photograph,
3 1-2 feet long, 10 inches wide, free to each dealer.
Mention this in your first order. We guarantee every
card good as sample.
THE BEACH CARD STUDIO REMSEN, N. Y.
Boys making $3.00 per day selling these cards

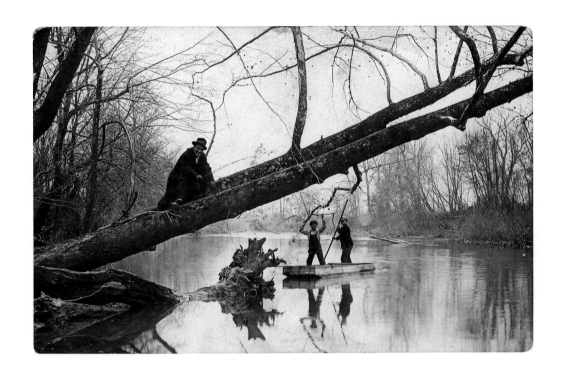

HANDWRITTEN:

My Boy. Do you see the old loon on the log and do you know him. Frank is in the boat. This is a good place to fish. Surviving here today, first river [ILLEGIBLE] to Mom Dad + all
G.Pa

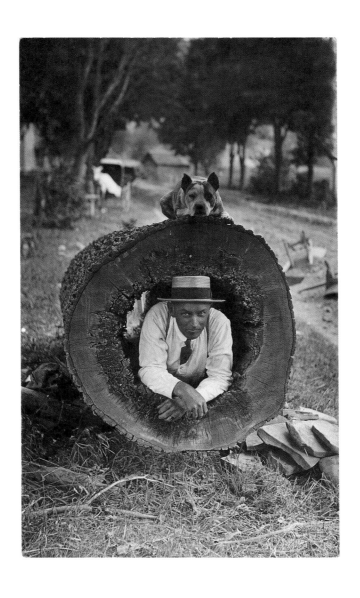

HANDWRITTEN:

S. Otselic, NY Chewango, Co.

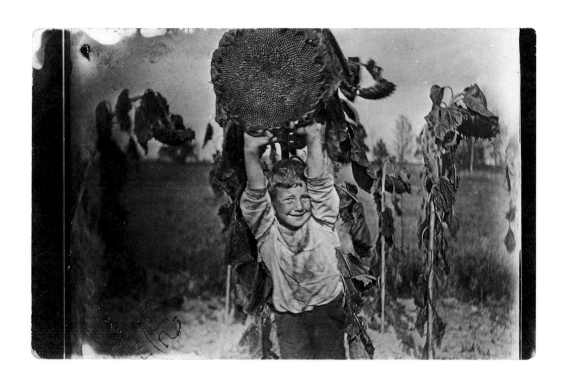

INTERVIEW WITH HARVEY TULCENSKY

BY LAETITIA WOLFF

As the name implies, an amateur is one who works for love.
—ALFRED STIEGLITZ, 1899.

Started some twenty years ago, the collection of Harvey Tulcensky has grown to include about three thousand real photo postcards, covering mostly Americana but also a few European social tableaux and unique surrealist montages. A selection of these cards was shown in New York for the first time in 2004 in a show entitled "Postmarked" at K.S. Art. The cards are mostly black and white and sepia toned with some cyanotypes, tinted and hand-colored postcards. They are all actual ("real") photographic silver prints developed in the darkroom, mostly in one-offs or limited editions.

As an artist, Tulcensky brings his visual thinking and a unique aesthetic sensibility to the acquisition of the cards. Real Photo Postcards *is about the cards, not their history or evolution. The collection is interesting in that it was gathered not for scholarly purposes or for the cards' place in history, but for their intrinsic richness—or, if you prefer, the aesthetic qualities the artist found in them.*

These true miniature gems pay homage in their own way to the early years of photography while fulfilling a personal passion.

* * *

LAETITIA WOLFF: How and when did you start collecting?

HARVEY TULCENSKY: I started collecting postcards in the seventies, when my parents moved to Miami, Florida. Every time I visited them, I stopped at the hotels along Collins Avenue and picked up a handful of their promotional postcards. My project was to gather and arrange them serially—with or without specific manipulation, right side up, upside down, etc. I was using the same imagery repetitively with their gaudy colors to create repetitive structures of pattern. I was somewhat influenced at that time by the work of Ed Ruscha and Dan Graham.

LW: What prompted your interest in the particular photographic genre of photo postcards?

HT: I did not start collecting again until 1984 when I bought land in Vermont with the intention of building my own house. I went around looking for historic images of Vermont to become more intimate with the place and to get ideas. I wanted to project myself into a particular past and immerse myself in the personality of a particular locale, to become closer to its soul.

At first I discovered cards in antique shops and used furniture stores; they always had a shoebox filled with old cards. I found them fascinating, far beyond their pure historical value. Many of the images were simply poignant. I immediately noticed that among these ordinary cards were some particularly beautiful ones that were different from the rest, and these were the real photo postcards, not mechanically reproduced cards.

LW: As an artist, did you have another project in mind?

HT: It was in Vermont that I seriously began collecting cards for the sake of building a collection. Although I had always thought I would make art with these cards, either drawing on them or drawing from them, somehow this became secondary, and collecting became the larger project. I became obsessed with finding cards, searching for images I hadn't seen before, and the art became the form of the evolving collection.

LW: Were you looking for something specific then? What are you looking for now? How has the body of work evolved over time?

HT: I was looking for the soul of a place, trying to situate myself in it to build an imaginary world through these cards, to construct an artificial history of a locale that had existed before me. By the time I built the house—four years after I had purchased land—the cards I was acquiring were of a finer quality, and I was discovering better sources for the material.

At first, I focused on early twentieth-century New England. When dealers realized I was serious about collecting, they told me where I could find special cards. Once I started attending professional organizations, I realized that what I had gathered until then was quite narrow (most of the cards were photos of houses, farms, and bucolic landscapes). The pictorial world of these cards was much larger than what I had been previously exposed to. I began searching for the most compelling images I could find—and they did not have to be of Vermont. It began as a quest for quirky, memorable, and unusual imagery, and still is. By that time I knew I wanted only real photocards.

LW: If anything were possible what would you collect?

HT: I've learned that a large part of collecting is accepting limitations: what I put back is as important as what I buy. What is the best of what I see? What do I really collect? What adds to the collection versus what is just more of the same? I prefer to constantly have to make judgments and edits about what's more significant to me. I think total freedom would actually diminish the quality of the collection and the act of collecting.

LW: What do you think is missing in your collection?

HT: I'd like more cards that are deliberate, self-conscious attempts at art-making or image-making rather than merely recording an event or place; however, I generally do not realize something is missing until I come across it and a new possibility opens up. I think of collecting as a means of discovery, where I can always

fill in the gaps of missing or under-represented categories as it becomes evident. At some point I felt I needed to include more exaggeration cards—a sub-genre within the photo postcards—although at first I was not so impressed by them. I was attracted to the more subtle collages that were harder to decipher. However, as I expanded that category, I made a conscious effort to also include the obvious exaggeration cards. Also the copy line, which is hand scratched on the surface of the negative, is often very humorous.

I don't have many portraits, as I actually find most of them boring. Most subjects stand blankly in front of the camera, not knowing what to do or how to look natural for the extended exposure times of the period. Only rarely do these portraits communicate depth or personality in the sitter.

LW: What gives you the most pleasure in your cards?

HT: Every time I look at them, I discover something new, such as a detail I had not noticed before. I appreciate their depth and the minutia of information that can be contained in such a small space. I'm always taken aback at how exquisite they are. I contemplate them, remembering when, how, and where I found the card. Yet, I always see them anew. Now that the collection has grown, each card seems to bear a meaning relative to the whole of the collection, like elements of a puzzle.

LW: What details are you particularly attracted to?

HT: I know what I am looking for immediately. I can go through a bunch of cards and immediately put back what doesn't interest me. I then sift through the ones I've chosen and compare these with cards I have. I pick a few cards that seem perfect and use those as a scale against which I measure others.

But it's different with each card. A card can be degraded, damaged and still be beautiful, even more so because of the alteration. Another card may be perfectly sharp, with no abrasion, and be of no interest to me.

Ultimately, what's important is that a card moves me.

LW: Describe your approach in picking cards, specifically the more abstract and artistic categories.

HT: I am attracted to night photography because I like its romanticism, its lyricism, the mystery of what's left out. I am fascinated by the effects of artificial light, which at the time was a novelty. In many of the best cards, it is used playfully for effect more than for documenting anything in particular. I have always been interested in architecture, and as a child I wanted to be an architect. So many cards have a distinct structural composition, others include a detail in carpentry, geometric balance, something that makes the structure particularly remarkable to me, but I won't get the card if it doesn't hold up. Clearly I'm attracted to the modernity of perspective that many of the cards exhibit, in the sense that Degas or Lartigue or even Japanese Ukiyo-e prints redefined our way of looking, with compositions that still seem fresh to our now historicized eye.

LW: Describe what major cultural shifts these images record.

HT: They document obvious historical revolutions such as the new technologies of the turn of the century—from a simple, relatively inexpensive camera that could be used without much technical knowledge to flight and electric light, from automobiles replacing horses to the popularization of the telephone. Others are nostalgic statements of a time that no longer exist, when America was mostly rural but in a state of transition to an urban culture.

Paradoxically they also mark a technological moment that may have lead to their demise, to their falling out of popularity: i.e. the emergence of the moving image and ultimately television. The cards are riveting in their details, but once images started to move and expand to the scale of a large screen while fabricating a narrative for the viewer, the smaller, static cards became comparatively less compelling and relevant.

LW: What did you learn from the writing on the back of the cards?

HT: For the most part, I learned that the messages have very little to do with the images and that people had beautiful handwriting but were not necessarily good spellers. I often wonder what crossed their minds when they picked an amazing card without making any reference to it in the written message. Many of the cards were actually never mailed, while others were mailed within envelopes (which may say something about the perceived magic of the imagery).

LW: Do you collect specific photographers?

HT: Not really, but as I collect more and more I become aware of particular names: William H. Martin & Company, for instance, specialized in exaggeration cards; Butcher worked extensively in the western prairie; while Snowflake Bentley documented snow crystals in Vermont. But generally I am looking at a card, not at a particular photographer; I am more interested in individual images.

LW: Explain how this photographic genre connects with the history of photography at large.

HT: It is an idiosyncratic, spontaneous, naïve branch that often lacks the formality of the better-known larger format photography. Real photo postcards are the result of putting the camera in the hand of the everyman, not just the privileged. These photographers were not necessarily official or self-proclaimed artists, but people who nevertheless made wonderful art.

LW: About this notion of truthfulness, do you think contemporary photography has lost the authenticity that these cards still convey?

HT: There is an absence of artifice that renders these cards fresh a hundred years after their making. For the most part, they are not self-conscious attempts to make art, and even when they are, it is often naïve. The medium is still in its relative infancy and is essentially a process of discovery of itself and of a new era and of an expanding and shrinking world. It's in this way that these cards seem particularly authentic and refreshing.

ACKNOWLEDGMENTS

..

The authors wish to thank Kerry Schuss who first exhibited a selection
of these cards under the title *Postmarked* at his New York gallery, K.S. Art,
in May of 2004; Todd Alden for his insightful essays accompanying
the exhibition and this book; and to Norman Brosterman; George Gibbs,
Anthony D'Offay, Luc Sante, Joe Vasta, and David Winter for their
passion, interest, and support.